Success in
PORTRAIT PHOTOGRAPHY

Jeff Smith

AMHERST MEDIA, INC. ■ BUFFALO, NY

Published by:
Amherst Media, Inc.
P.O. Box 586
Buffalo, N.Y. 14226
Fax: 716-874-4508
www.AmherstMedia.com

Publisher: Craig Alesse
Senior Editor/Production Manager: Michelle Perkins
Assistant Editor: Barbara A. Lynch-Johnt

ISBN: 1-58428-088-3
Library of Congress Control Number: 2002103388

Printed in Korea.
10 9 8 7 6 5 4 3 2 1

Table of Contents

Success ... it's the one thing that everyone seems to be looking for, but many people don't even know what it is. Is success *wealth*? Many people think their only opportunity to become very wealthy is to play the lottery or be discovered by a talent scout. Well, wealth is a simple enough thing to create. You spend less than you make and stick the rest of your money in an interest-bearing account. When you get into this habit, interest compounds, and you'll create your own wealth. But is that success? There are many wealthy people that take their own lives and, as far

Creating fabulous images is the goal of every photographer, but to achieve success in the field, you'll need more than talent.

Introduction

When you decided to become a photographer, you probably planned to be a success. Are you satisfied with the direction that your business has taken?

as I know, no one has ever been able to take their wealth with them when they crossed to the other side. I've never heard anyone say, "Damn, here I am dying today, when Bloomingdale's is having a sale on Saturday!"

Is success about *fame* or *notoriety*? If you asked several people, "who do you think is successful?" many might say Donald Trump or maybe Madonna or, if they are photographers, maybe Don Blair or Larry Peters. Many photographers struggle for years to get their Craftsmen or Masters from PPA (Professional Photographers of America), but will they be any more successful when they have that ribbon to hang around their necks? Here is something to think about: some of the wealthiest portrait photographers don't have their Craftsmen or Masters, and some who have their PPA degrees will never make a decent living in photography.

After my second book *(Outdoor and Location Portrait Photography,* Amherst Media*)* came out, I received many e-mails about speaking dates. Many photographers asked me to come to their area to put on a program. My first thought was to call the PPA local associations in the areas of California that I received the most e-mail from. Many of the people I spoke with were very nice and helpful, but there was one guy . . . we'll just call him Mr. Pocket Protector.

Mr. Pocket Protector worked out of his home, which is fine. He had an old answering machine that made him sound like he was at the bottom of a deep cave. After leaving several messages, he returned my call. After I explained why I was call-

ing, the first question he asked was whether or not I had my Masters from PPA. I responded, "I am a member of PPA but, no, I don't have my Masters" (as a matter of fact, I'd never entered a single print!). Although I thought this was kind of funny (in an ironic way), he was not amused. He told me he would never help with a program if the speaker didn't have his Masters—and then talked for three or four minutes about how I could get mine.

When he finally finished he asked me what qualified me to give a program anyway (as if three books and all the articles I'd written weren't enough?). To drive the stake right through his Pocket Protector, I told him, and I quote, "I make a lot of money in this profession!" If I'd reached through the phone and slapped him, I don't think he would have been any more shocked.

After our verbal "Battle Royal" he attempted to be polite and asked me to send my books and all the articles I've written to him, along with an outline of the program I was planning. He said that he'd give the information to the person in charge of programs.

I called back three weeks later to see if he'd received the materials, and guess what? Mr. Pocket Protector's phone was disconnected. I called another person in the local association who informed me that he'd packed up and left town because he was going belly-up. So is success about fame, recognition, notoriety, ego or arrogance? I think not. Fame, recognition and notoriety have a tendency to turn a person who isn't successful into a jerk. Their entire being becomes wrapped up in the fact that they've written a book, won an award or finally have that ribbon to hang around their neck.

Is success about *happiness*? Not completely, but I believe it's the most important quality listed so far. When I say happiness, I'm not talking about being one of those people who constantly tells everyone how happy he or she is. Happiness

is like being a person of faith. If you truly are, you don't have to tell anyone, for they can see it for themselves.

Is success about fame or notoriety? If you asked several people, "who do you think is successful?" many might say Donald Trump or maybe Madonna or, if they are photographers, maybe Don Blair or Larry Peters.

Working with the employees in our studio over the last eighteen years, I've seen the impact of watching too much television and buying into a made-up, larger-than-life picture of happiness. Most people seem to think that once they obtain some specific, magical goal, every other aspect of their lives will fall into place.

As you get older, you start to notice things. Working with the employees in our studio over the last eighteen years, I've seen the impact of watching too much television and buying into a made-up, larger-than-life picture of happiness. It usually goes something like this: "I'll be so happy when I meet Miss or Mr. Right!" "Well, I finally met them, but I'm still not happy. Maybe I'll be happy when Miss or Mr. Right and I are married." "Well, we're married now, and I'm still not happy yet, but we'll be so happy when we have a baby." "Well, we have two kids, and I'm still not happy—but we'll be so happy when I get that new house." Well, we have our house, but I'm still not happy yet—maybe Mr./Miss Right wasn't "right" after all! When I divorce that lazy slug/mean shrew and find my true soul mate, I'll be happy at last!"

No possession, no mate, no child, no profession will ever make an unhappy person happy. You can give an unhappy person a million dollars and, after the newness wears off, he or she will be a miserable person with a million bucks. Happiness has nothing to do with circumstances, it only has to do with you. Some of the happiest people in the world have little in the way of material wealth, but they enjoy each day of their lives.

Is success about your *work?* The average American spends more time working than just about anything else, other than sleeping (and if you have children and a business, you probably

spend much more time working than sleeping). So, to think that you can be successful if you don't like your work is just plain ridiculous. As a matter of fact, a person usually becomes a success because they love what they're doing. The enjoyment of their career is what leads them to excel beyond others in their profession and, consequently, allows them to fully enjoy their lives outside of work. When you get ahead of your competition, the rewards of your work and your life really start to pay off.

One of the most important contributors to success is being in touch with reality. This is the key to success in everything. Don't expect things to be perfect, for they never are. You can be in the most beautiful vacation spot in the world. Even an-all-expenses-paid romantic getaway with your spouse or significant other will be less than ideal, for nothing is ever perfect. You may get into a big fight with your partner, have a bad flight or meal or a dead fish may come floating up as you're snorkeling near those beautiful beaches. That's life—and while a few people realize that small problems are a part of life, most continue to let small problems destroy beautiful vacations.

The same is true for your work. Some photographers have carved out a niche in a small community, where they photograph everything from weddings, to children, to pets to livestock. They like the people in that little town and the people like them. If that's your cup of tea, you must realize that with a small client base, you'll probably never drive a Mercedes or live in a large house. That's being realistic. If your work brings you enjoyment and you (and your family) don't need the material things that a larger business in a larger area might bring you, you'd be an idiot not to think of yourself as successful. Success isn't just about money.

So, what is success? Simply put, it is defining what *you* want out of life and going after it. Call it goals or direction, but you have to know what you want, and realize both the good and bad points of your choice, then go after it with everything you've got. If you're married—and especially if you have children—any decision you make should be one that your family can live with too. Children need parents, not some schmuck that thinks he/she is working ridiculous hours for their children, because they aren't. Someone who works 100 hours a week does it for themselves, not for their spouse and certainly not for their kids.

So, what is success? Simply put, it is defining what you want out of life and going after it. Call it goals or direction, but you have to know what you want, and realize both the good and bad points of your choice, then go after it with everything you've got.

Many people set and obtain goals, but they don't realize what they're doing. If you're married, think back to when you were trying to attract your wife or husband. You thought you'd found the person you wanted to spend your life with. If you're a guy, you started showering after work. Your started picking up your apartment and taking the dirty clothing off the floor so your apartment wouldn't smell like a gym. You went to all kinds of restaurants and events that you really didn't want to attend (and may have even hated), but you did it because you had a goal in mind and you just kept reminding yourself of that goal.

That's how anything worth having is obtained. You don't try for a while and quit.

That's how anything worth having is obtained. You don't try for a while and quit. You don't look at every obstacle in your way. You focus on what you want. Then, when you think of giving up, you remind yourself of what the reward will be.

This book is different from other photography books. Most explain the author's theories about lighting or posing or explain how that particular photographer achieved his or her success in the profession. This leads the reader down the same path as the author. Well, I don't want you to take the same path as me, or Don Blair or Larry Peters for that matter. I want you to read this book and choose your own path. The success I've found has nothing to do with you, because you aren't me. If most photographers were to drop into my studio at the end of August, they'd run for the door (yearbook deadlines, so many seniors!). Although I love what I do, it isn't for everyone.

You can't get to someone else's destination or reach someone else's goals. Your mom may want you to be a doctor, your Uncle Harry may want you in the family business and your father may want you to be a linebacker for the Pittsburgh Steelers—or the next women's tennis star. These are their dreams, not yours.

You obviously want to be a successful photographer or you've really gone astray in the bookstore. Just wanting to be a photographer isn't good enough. You can't get to a destination without determining a specific course. If you do, you'll end up just like the photographers that shoot weddings just because that's what the photographer who taught them photography shot. I know people who absolutely hate doing weddings, and yet they photograph weddings week after week, year after year. Weddings may provide you with a good income, but if you hate what you do, you'll never be successful.

How can you do your best if you're not enjoying what you do? You can't. No matter how you

You can't get to a destination without mapping out a specific course.

CHAPTER ONE

Finding Your Own Way

fake it, you'll never produce your best work if you don't enjoy it. So what do you do? First, decide what type of work you're passionate about. What type of photography could you do, every day, for the rest of your life and never tire from? To be effective, you have to be honest with yourself. Many male photographers would automatically answer, "I'd never get tired of shooting glamour, boudoir and model sessions." Letting your libido guide your career choice is just as bad as letting your mother choose your path for you!

◆ PLOTTING A COURSE

Let's say it's not your raging hormones—you actually like photographing models for portfolios. There aren't too many aspiring models pulling in the big bucks. As a matter of fact, you can go to almost any restaurant in the Los Angeles area and find a would-be model/actor getting your coffee or busing tables. While this type of client may exercise your creativity, large sales are going to be few and far between. That's reality. There are some very successful photographers that specialize in portfolios, but most are barely getting by.

Weddings may provide you with a good income, but if you hate what you do, you'll never be successful.

In the '80s every portrait photographer had to offer boudoir portraits—it was almost a law. Boudoir photography was all the rage. Women were flocking to photographers in droves, with their teddies in hand. I listened to speakers talking about the $1000–$2000 sales that were possible. So, like many photographers, I bought into the whole idea.

In reality, I found that most of my boudoir clients were in their early twenties, holding down a minimum wage job until they met the "loaded" man of their dreams. We also had many clients who were on the losing end of a recent divorce and wanted a photograph to help with any new

prospects. Either way, the sales were not what I was expecting.

On top of that, I had to put a lot of time into each session. I'd spend an hour or hour and a half making these clients look good, only to have them buy eight wallets (only because they couldn't get just one!) and a 5x7 for Mr. "Right Now" to put in his desk drawer. As you can tell, shooting boudoir or modeling portfolios wasn't where my sights were set.

Further down the list of unpleasant clients was children. I personally disliked them and do to this day, with the exception of my own. I found that weddings were a monumental waste of time per dollar earned. I was completely honest with myself and decided I had to specialize in families or seniors, because I loved doing both and I was good at it. I was only twenty when I opened my studio, so seniors looked at me as one of their own, while most families that had the means to afford what I was doing were put off by my baby face. Senior photography was the direction I chose.

After deciding to specialize in seniors, I found that the path was filled with problems and setbacks. I was entering into one of the most competitive areas of professional photography. I started to specialize in seniors just before Larry Peters started speaking all over the country about all the money that could be made in the senior market. And if you think that marketing to seniors is competitive, you should try swimming with some of the sharks that contract various high schools to get their seniors. They have corporate money to spend and a promise they probably won't keep for every occasion. I'm not complaining, just pointing out that no matter how fierce the market you're entering is, you can succeed. You just have to decide where you want to be, and you can't stop until you get there. The biggest obstacle for most people isn't achieving their goal, it's overcoming the roadblocks along the way.

Deciding on the type of clients you want to work with is easy, but ignoring the advice you get from others is difficult. Trust your judgment, and begin to develop your goals.

Opposition. Deciding on the type of clients you want to work with is easy, but ignoring the advice you get from others is difficult. It seems that some people just want to stop you in your tracks. I was asked why I wanted to be a photographer, why I didn't just get a regular job with benefits and a retirement package for a secure future. When I opened my business, I was told the economy was depressed. "After all, we are in a recession," someone said. "Just pack up and reopen in a few years." People in the know told me I was ridiculous to put all my eggs into one basket and specialize. I was told that opening a new studio in a larger city was much harder because of all the competition, and that we would probably never make it.

Let me give you a good example of the world we live in. Pick any type of client you want to work with exclusively. Whether you really like working with them or not, it doesn't matter. Let's say you picked working with children. You go to your spouse and tell him/her you want to start working only with children, or at least that's the direction that you want to work toward. Most of the time, your spouse will have a less than excited response to your newfound direction. This doesn't mean

that your spouse is a bad person, but changing your business could mean a loss of income or it could bring about changes in you that your spouse may not like. In marriage, change isn't always good.

Now, take your newfound direction down to the local camera store—the one that all the photographers meet at for coffee each morning—or go to your local association meeting. Once you've met up with your peers, tell them about your newfound direction. For every person that responds in a positive way, you'll encounter five or ten who'll give you all the reasons why you shouldn't go in the direction you've chosen. You'll hear the market is depressed or that there's another great studio that already specializes in children or that it's stupid to put all your eggs in one basket. But wait a minute: if these photographers had found their niche and were running really successful businesses, would they have time to hang out around the coffee pot every morning? The same is true for association meetings. If I have a free evening, I'm not going to spend it with a bunch of photographers. I have a beautiful wife and two great kids. The point is this: we live in a negative world and we ask the wrong people for advice.

Your spouse is too personally involved with you to be completely objective. I know when my wife talks about possibly doing something else (other than running the studios), it scares me to death. I think, "My God, who am I going to get to replace her? Can I replace her? I'll lose all my schools! Is our family going to be living in a cardboard box? No more nice clothes, no more nice vacations, all because she wants to try something new?"

Some Advice. I have two suggestions for planning for the future. First, only take advice from

Success is about striking a balance between your personal and professional life. It's about feeling that you're succeeding both as a professional and a person.

someone who is where you want to be—a happy, financially successful businessperson who doesn't have a great deal of time to hang out at someone else's business. Make sure the person you accept advice from smiles more than they frown, has more solutions than problems, more good clients than problem clients and a family that they speak proudly of. These are all good indicators of a successful person.

The second piece of advice is to use common sense. Once a person discovers where his passion in business lies, he tends to try to make a leap, diving headfirst in that direction. I didn't decide to

specialize in senior photography and then simply quit doing everything else. I slowly started making changes in my business to get to my destination.

Success is about achieving balance in your life. Although my studio and my profession take up a considerable portion of my time, my job is only what I do, my family is who I am. Success is about striking a balance between your personal and professional life. It's about feeling that you're succeeding both as a professional and a person. There's not one ounce of truth in the old saying, "you pay the price of success," because *you* enjoy success. You pay the price of failure—and believe me when I say that the choice is yours.

Specialization

Specialization in one or two areas of a profession isn't a new idea. Doctors, lawyers and architects, as well as photographers, have found that to work with one or two types of clients in their profession gives them the ability to focus their learning on that specific group. General practitioners have to dilute their concentrated skills. Instead of specializing in the needs of a particular client, they must meet the needs of every type of client to be effective.

Most studios in the country are general practice studios. They photograph screaming children one minute and deal with a nervous bride the next. We know that repetition is the key to learning, and these photographers can't focus on a particular type of client. Here's a helpful analogy: you may be a good driver, but if you go down a mountain road that you've never driven down before, you'll feel that you must creep along to not lose control. A person who drives this same road every day can

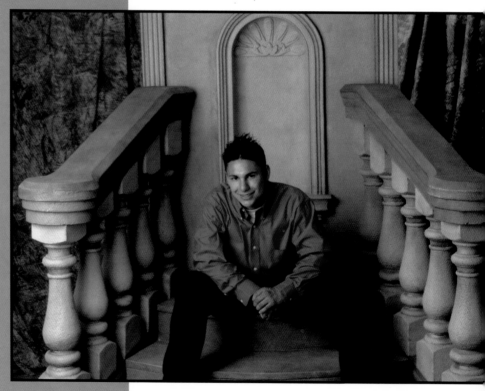

Specialization is a wonderful thing. It allows you to direct all of your resources—from marketing to prop selection—to a very specific client base.

take each curve with ease—while exceeding the speed limit. For general practitioners, weeks can pass between one senior portrait session and another. A photographer may struggle to remember what poses, lighting and backgrounds she used. Just when she starts feeling comfortable, the session is over and she'll have to wait another week or two before she photographs another senior.

There are two losers here: (1) the photographer, who'll never do her best work because she's constantly struggling and, (2) the client who's stuck with photographs that are far from top-notch. The jack-of-all-trades, in most cases, is truly the master of none.

When you specialize, you can purchase props, backgrounds, sets and posing aids that suit the clients you work with. Today, clients of every type expect a larger selection of backgrounds and sets than ever before. Successful photographers need more than eight backgrounds and a white wall to be successful. In fact, most backgrounds and sets are client-specific, meaning that few are popular with more than one type of client. The sets that seniors love will be worthless when it comes to traditional portraiture. The specific miniature props and posing aids that are used for children and babies are unusable with any other type of client. In a general practice studio, you have to have a limited amount of everything so you can work with everyone.

◆ THE PATH TO SPECIALIZATION

Specialization for some photographers just seems to happen, while other photographers have to take it step by step. The first step in specialization is actually fun and uplifting. You decide which type of client you hate dealing with the most. Once you make that decision, you start to raise your prices on that type of work to eventually price yourself out of the market.

I know what some of you are thinking—you need all the business you have just to get by, and here I am telling you to purposely send some of it away! You're right—that's exactly what I'm telling you to do. To be successful, you must send some business away. In my studio, I send away enough business in any given week to keep at least one, if not two, full-time photographers busy.

Fear is the number one reason why people never live up to their potential.

When we first open our studios, we're scared to death that we won't succeed. As our businesses grow, fear fuels our business decisions more than common sense. Fear is the number one reason why people never live up to their potential.

If you look at any general practice type business, you'll typically find that 80 percent of the profit (the money in the owner's pocket) comes from 20 percent of his work. The 80/20 principle applies to most areas of our lives. Look in your closet—it's full of clothing. If you are like most people, you wear 20 percent of your clothing over and over again. The other 80 percent of the clothing basically hangs there. What would happen if you gave 80 percent of your clothing to Goodwill and had a huge void in your closet? Nothing! You'd still have the clothing you wear all the time and, if you're like most people, in three months your closet would be full again.

The same thing happens in business. Hopefully, you've decided to specialize in the area that generates 80 percent of your profit. If so, the process of specialization will be simplified. If you find that most of your profit is derived from the type of clients you *hate* to photograph, the path to specialization could be a little bumpy. It'll take more time to reach your destination, but it can be done.

When I decided I wanted to specialize in seniors, I wanted to cut weddings. From a business standpoint, this was hard at the time, because

*Deciding on the type of clients you want to special-
ize in will help you to excel in your business. For me,
the decision was an easy one. From the start, I real-
ized that I really enjoyed working with seniors.*

weddings were a major source of cash flow. But I
really hated the time and energy that weddings
required. Once I made the commitment to cut
down and then eventually stop doing weddings, I
raised my wedding photography prices 25 percent.
After six months, I raised them another 25 percent
and after a year I raised them again.

In raising my prices I accomplished several
things. First, I booked fewer weddings, which
gave me more time to spend working with seniors,
who always wanted Saturday appointments. The
increased profit made the few weddings I did
shoot more bearable, and I found myself doing a
better job for each couple. While I was charging
several thousand dollars to photograph the last

◆ STAYING HOME

Many photographers like working out of their homes so much they stay there, while others reach a point where they are so busy that their spouse asks them to get a studio building. At home, every dime beyond the lab bill and basic expenses is profit, and your work space is considered a tax deduction. Your profit can be used to open a studio, or you can just stay at home and work on early retirement.

A home-based business can be very successful and gratifying. There has been a shift in public attitudes about professionals who work out of their homes, and the decision to run a home-based businesses has become more acceptable. This is the age of the home office more and more professionals are working at home to spend more time with their families. From profit to family time, staying at home really offers a lot of perks.

◆ BUYING/RENTING A STUDIO

When business increases (or your spouse has had enough), you may find yourself looking for a bigger space for your business. As exciting a move as this is, you need to exercise caution before purchasing a higher-profile location. Studios fail when photographers open their doors too early in their career. They wind up staring at the phone, waiting for it to ring, and use up all the money they've set aside, hoping for success all the while going down the exact path that proved to be a dead end for someone else.

Photographers are notoriously bad at business. The success rate of a start-up photogra-phy business falls well below that of other professional service providers. Why? Because most photographers take the same steps that everyone else has taken and think they ll end up at a different destination. They think their special talent and unique abilities will save them.

You see the same thing in other businesses: someone buys a failed restaurant, re-opens in the same location, serves the same food, sets the same hours and then wonders why he struggles to pay the bills. In photography, it usually goes something like this: a friend tells a would-be photographer she takes nice pictures and should charge for her tremendous talent. She gives those comments some thought, but realizes she doesn t have the experience to open a business. So she sets out to attract clients and gain experience while working out of her home. It seems like things are progressing. She sees improvements in her photography and hears positive comments from people especially those that get the free photographs from test sessions.

Once bitten, many photographers with large egos, little business experience and a simplistic view of the American dream decide to open a studio. They believe that opening a studio will magically draw a better client base between word of mouth and exposure gained with a new studio building, they figure that clients will be coming in by the truckload. They find a location and wait for the clients to come in . . . and they wait, and they wait and they wait. While they re waiting, the start-up capital they need to keep that bigger studio afloat just isn t coming in.

few weddings I shot, I still preferred to work in the studio on Saturdays with seniors and spend Saturday night with my family.

Freeing up some of your time by giving up a certain type of client won't pave the path to specialization. It will simply give you an opportunity to focus your attention on the segment of the market you're most interested in. Once the decision is made, you'll need to attract that segment of the market to your studio.

Marketing. In any business, you must create an image that reflects the tastes of your target market. Everything from the message contained in your radio ad, to the color scheme you use in your print advertising, to the interior of your studio must suit your clientele. The portraits you display in your studio and the music you have playing in the background must also appeal to your target market. By taking these steps, your target market can identify with every part of your business.

When you get really good at this, potential clients should be able to gauge what type of portraits you offer and roughly what they can expect to pay—at a glance. The images displayed on the ad, the colors you select—even the quality of the printing and the layout—should speak volumes about your studio.

The Studio. When a person walks into your studio, they should know right away whether or not your studio is right for them. When a potential client walks into our studio, they see nothing but senior portraits. A bride-to-be or mother

Top: With the volume of phone calls we receive, a phone room and larger phone system is needed. The room and partitions ensure callers don't hear studio noises. A professional quality phone system gives the caller the feeling they're calling a professional business, rather than a small studio with one employee who's waiting for the phone to ring. Center: We contract high school seniors, which means our furnishings have to be stylish enough to appeal to the more affluent seniors, without scaring away the seniors with more limited budgets. Bottom: With changes in technology and our many new sets and backgrounds, we're always reconfiguring the studio. We've found that it's much easier to frame partition walls and then cover them with thick muslin instead of sheet rock. (We don't do this for the sales areas or the front of the studio.) It's faster to put up and doesn't require demolition to take it down.

looking for children's portraits will know right away that she's in the wrong place. The color schemes and furnishings used in the studios are slightly upscale, but are modest enough not to scare off any of our contracted seniors, some of whom have modest budgets. The music is a little louder than in most businesses and is always set on the station that the high school seniors listen to the most.

Most photographers never think about their studios in these terms. They pick out everything according to their personal tastes—*without* thinking about their clients. Many photographers in a general studio display portraits they like, rather than using their display portraits to help define their business. I have gone into studios that photograph many seniors, but they have nothing but wedding and children's portraits on display. This would be like going into a Chinese restaurant and seeing sombreros and Mexican blankets all around for decoration.

In any business, you must create an image that reflects the tastes of your target market.

Price. Many photographers want to charge more for their work, but they have an old torn sofa in front of their studio that's been there since the '70s. Some studios select furnishings that are too nice, and this can also be a problem. If you walked into a restaurant and saw fine art on the walls, overstuffed chairs at each table, and columns and marble floors as far as the eye could see, your heart would start racing. You'd turn and leave before ever looking at the menu—and never find out that they had good food at reasonable prices!

Every visual aspect of your business should speak specifically to your target audience. Whether you're decorating your studio or designing ads, make sure that your appearance reflects the level of service that you provide.

arketing, or the means you use to attract potential clients, is way too complex a topic to cover in a single chapter. There are, however, many simple principles of marketing that can help you reach your goal. First is the amount of resources you devote to the types of clients you work with. You can't work toward specialization without devoting more time, energy and resources (money) than you currently are.

Targeting the Clients You Want

◆ TIME, ENERGY AND MONEY

Time and energy are at one end of the spectrum and money is at the other when it comes to putting together a marketing plan. When you have the resources (money) to do what you want to do, you have very little time or energy, so you have most of the work done for you by an outside company. When you don't have the resources, you

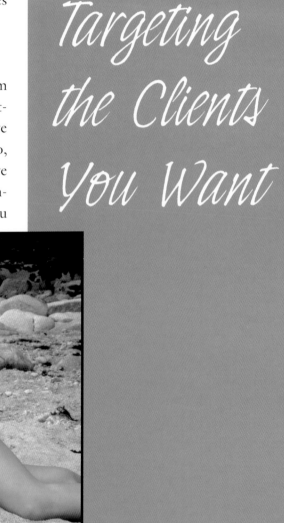

You can't work toward specialization without devoting more time, energy and resources (money) than you currently are.

have all kinds of time and energy to think up and implement low- and no-cost ideas that will earn a portion of the market.

Poverty is truly the mother of invention. If you don't believe me, ask yourself who came up with ideas like exhibiting your work, referral programs, ambassador programs for seniors, newsletters and all the other low-cost marketing ideas. Was it a really successful person who was dripping with cash, or a person who had few resources and was forced to use his imagination?

There are so many ways to get your name in front of the people who make up your target market. You just have to use the tools that reach the most people in your target market for the least time/energy and money invested. Your marketing strategy will depend on your target market. While direct mail and an ambassador program work well with seniors, you may use a weekly newspaper or newsletter and a referral program for children or families. The choice is yours—but you'll need both resources and imagination.

◆ MISGUIDED DOLLARS

Once you've decided on the most effective means to get your message out, stick with it. Don't let a salesperson selling radio time, newspaper ads or a T-shirt with your company's logo on it talk you into parting with one dollar. If you've decided to put your limited resources into direct mail or a weekly newspaper, that's where you need to spend that money. Don't let some salesperson with the Yellow Pages talk you into a display ad because that's what your competitor is doing.

Far too many misguided marketing dollars are spent on hiring companies that design web sites. We have a web site. I designed it myself and it's an important part of our marketing plan, but the truth is, web sites tend to mean a lot more to the business owner than to the potential client.

There are many ways in which you can attract your target audience, but be sure to do your research before committing your hard-earned dollars.

Through our site, seniors can get everything from a map to any of our outdoor locations to tips on how to dress for the yearbook portrait. It's 20MB and full of information and portraits (all for $39 a month!). But don't think that just having a web site, no matter how well it's designed, will do your marketing plan any good.

A web site is basically a big brochure blowing through the vast spaces of the Internet. Without a reason to look at your brochure (web site), no one will visit. To encourage our seniors to visit our site often, we post new portraits every month, give away trips and give seniors whose portraits are posted on the site free wallets for every five of their friends who e-mail us. Working to keep your site new and exciting is important—it's the only way to keep clients interested in visiting. Even large e-tailers have to constantly advertise their sites to keep people coming back.

If you're good with computers and can design a web site yourself, it's well worth the time invested. If, however, you have to pay top dollar for a web site designer, your money will probably be better spent elsewhere.

◆ THE TWO RULES OF MARKETING

The first rule of marketing is repetition. Your business name must be received between four and six times for the average person to even remember it. The idea that using one person to spread the word about your studio, buying one ad, sending one mailer or securing one television or radio spot will fill your appointment book is ridiculous.

There are two factors working against your marketing plan. The first is actually getting your studio's name to your target market four to six times. You have to realize that a past client's opinion may not be respected in his/her circle or friends. They may talk a lot without having any impact whatsoever. We run into this with our ambassadors/reps in our high schools. Some of them *have* followers

and some of them *are* followers. Followers are of little benefit to the studio.

If you purchase advertising, the odds are even worse, because your advertising time is an opportunity for most people to go to the bathroom, change the channel or—in the case of print advertising—use your advertisement to start their next fire. To purchase enough advertising in any medium (other than direct marketing) is enough to break the bank for most studios!

If you have to pay top dollar for a web site designer, your money will probably be better spent elsewhere.

The second rule of marketing applies to advertising (paid messages), and that is: buy in bulk. So many small studios buy mailers one at a time. This means they're paying a premium price. I know photographers who mail out as many mailers as I do but pay three or four times as much in printing costs, because each mailer is handled job by job. When I send in my mailers they go in all at once and I get a price of about $.16 apiece. This means I don't pay that much more for a 6x9-inch color mailer than running black and white copies at Kinko's.

The same is true for purchasing ads or airtime. No matter what you, it's going to cost a lot of money, but you'll pay a premium price by purchasing one ad at a time. Most of the time you can sign a contract for so many ads to run over the next six months or a year and pay for them month by month—and doing just that make more sense for your business.

Over the years we've tried radio and television and, while it was really cool hearing and seeing my advertisements on these media, they received little attention from our target market. We've used weekly papers and had moderate success, while daily papers and supplements have been a bust. When we used the Yellow Pages, they charged a small fortune for a display ad and the potential

clients who called only asked one question, "How much do you charge?"

In any mass advertising, you have to study the demographics or, in other words, the breakdown of the target audience—the age, sex and economic status of people that your message will reach. Then you have to look at the actual number of readers, listeners or viewers each individual station/newspaper has. This is a great deal of work—that's why most people rely upon the advice of the person selling the advertising.

If you're going to do any kind of advertising, call the five best clients you've had in the last year. Find out what radio stations they listen to, what television stations they watch, and make your advertising decisions from there.

No one knows everything about advertising, but you'd think an individual or business that can afford high ticket advertising would use some common sense. I've done some boneheaded advertising myself, although most of it has been at least partially traded-out (advertising traded for services).

The golden rule of advertising (and life) is never take advice from anyone who's making a commission on what they're selling you. You see so many boneheaded ads because a business owner listened to a salesperson. You see huge display ads in the Yellow Pages, spots on prime-time TV for a small speciality business, etc. Salespeople fill a needed role, but beware: some of these people could sell a set of new tires to someone without a car.

I've seen photographers spend hundreds of dollars on ads in a local weekly paper for their chil-

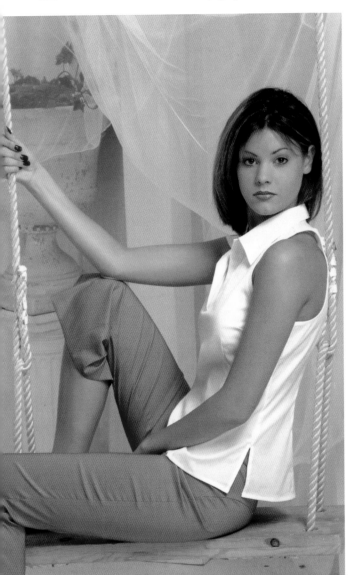

dren's portrait services (which the paper has the right demographics for) and then use the same paper for large ads on high school seniors. Seniors don't read newspapers and, statistically speaking, the paper is for younger families, so the ads didn't even reach the parents of seniors.

Through the years, I've seen photographers on television, heard radio spots that made no sense whatsoever and have seen advertising that meant much more to the photographer who designed it than the people who received it. I was at a convention at which one photographer, discussing his mailing strategy, admitted to leaving out the name and phone number of his studio (this was in front of a group of about 700 people). I appreciate his honesty, but come on, that's a bundle of money that did no good at all.

The most effective advertising exclusively targets your market. If you have mass appeal like McDonalds, you advertise in mass media (TV/radio). If your clientele is more specific, you must direct your advertising to a smaller group to get the most effective return on the money you invest.

As I was writing this section of the book I was in my truck, driving to the beach for a day of sessions (tough life, huh?). On the radio I heard an advertisement for tractors. Now, for any of you suburbanites, I'm not talking about a riding lawn mower here, but a huge tractor used to work farmland. Outside of the Monterey area is Salinas, a rich agricultural area where many residents are farmers. The boneheaded part of this is that the company advertised tractors—which few people, even in an agricultural area need—*on mass media* (radio). One out of maybe 50,000–100,000 people that the ad reached use a tractor and, if they were lucky, 1 to 5 percent of those people who use a tractor would have an immediate need and respond to the ad. The odds were slim that the company would get a single response to the ad.

At this point, the person in charge of advertising for this tractor company should feel like taking the salesperson who talked him/her into these ads out back to the barn for a good whippin'. As I said earlier, we tune our in-studio radios in to the stations that high school seniors listen to. Being that I listen to one particular station all day long in the studio, I've gotten used to it and I listen to it in my car, too. I don't know how many farmers you know, but I know many and when they listen to the radio, they listen to talk radio, maybe country, but not too many are really into Matchbox 20 or Smash Mouth.

Continuing with the bone-headed theme, we've purchased various items with our business name on them—from T-shirts to travel mugs, from pens to daily planners—and from a marketing standpoint, we could have just flushed our money down the toilet and been done with it (though a few of these items made nice gifts to the important people at our high schools).

It is very easy to use common sense when it comes to other people's businesses. You need to use that same commonsense approach when it comes to your advertising and marketing decisions. If you're going to do any kind of advertising, call the five best clients you've had in the last year (for whatever client type you want to attract). Ask them if they read the news-

paper and what radio station they listen to. Also ask whether or not they read single-sheet ads (postcards, larger ads) that come in the mail, and if they'd be more likely to open an envelope and read the ad inside. The questions can go on and

on depending on what type of advertising you want to do.

The same can be done for any marketing decisions. Make up a focus group of past clients (although they don't have to meet in a group) and get the needed information from them. They can decide everything from the paint colors for your walls to your business card design to the language you use in your ads. (We're lucky, because many of our employees are past clients, so we run everything past them to make sure we aren't off the mark. Many times, we've written ads using what we considered trendy sayings and our younger employees [former senior clients themselves] alerted us that we sounded like older people trying to be hip.) This way, you're sure that everything in your business is designed to the taste of the client you want to attract.

Giving your work away can be a powerful marketing tool, but you've got to be selective. Make sure to give free sessions away to leaders—people who will show off your work for you and really impact your business.

Another good idea is to ask first-time clients how they came upon your studio. This tells you what's working, although many times you have to use this information with a degree of common sense. A client might say she came to your studio after a recent mailing, giving you an idea to increase your mailings, but what *really* sold her on your studio were some of your past clients, an exhibit you did last year, etc. The mailer just happens to be the last thing she received, and she held on to it to keep your number on hand.

For the most part, there are two avenues of reaching our target market that always work, which is why I and so many other photographers use them. The first is direct mail. Without direct mail, I wouldn't have the successful business that I have today. The second is giving work away. If you photograph seniors, you might give free sessions to select seniors, who will then draw business for you. Find a person who travels in the right circles and get a wall portrait into their home—it really generates sales. This saved me from bankruptcy in those early years.

A few words of advice about giving your work away. First, be very careful whom you pick. Make sure you select the leader of whatever pack you're trying to reach. Social events are great places to see the pecking order in a group. You'll want to give your work to someone who will show it off,

You'll want to give your work to someone who will show it off, someone who seems to thrive in a social situation and seems to have many friends.

someone who seems to thrive in a social situation and seems to have many friends.

Make sure your studio's name and phone number are on every print you give away—no matter the size. Ask your lab to make a litho using the same typestyle you use on all of your stationary. Many photographers try to get artsy and sign their portraits, which is usually unreadable. If someone can't read it, there is no name recognition, so all your work is for naught.

◆ ANATOMY OF A MAILER

Since direct mail is the top choice of photographers who buy advertising, it's important to know how and why mailers work. Direct mail's growth in the advertising of professional photography has created some major problems, especially in the high school senior market. Seniors today are flooded with mailers from every studio in their area. All show nice images, most of them are in color and all but a few look exactly the same.

With all the mailers that go out each year, very few photographers have taken the time to study and learn what makes one mailer work, while another doesn't. What makes a client respond to one studio's mailing piece and overlook another? What types of mailers produce phone calls and what types produce potential clients?

In advertising, there are no *sure things*. Nothing always works. A famous advertising executive said that he figures about half of all of his advertising actually works. If he could only figure out which half it was, he would have something. Regardless, there are many things that can be done to increase the odds of success.

The best way to understand how to produce a better mailer is to understand what each component of a mailer is, and how it benefits the response rate of that mailer.

Images. The portraits in a mailer really capture the attention of the viewer. In the sea of mailers that seniors must go through, you can't show boring portraits. For seniors, unless you have portraits that are different than what they can get from their contracted studio, you're throwing your money away. Although striking images alone capture the viewer's attention, they do little else.

The copy tells the reader why your studio is unique and how it can benefit the potential client.

Headline. A good headline—a short, to-the-point bit of text—entices the viewer of a mailer to read the copy, which tells them why they should select your studio. A headline should entice a potential client: you can ask a question or make a statement that peaks their interest and makes them want to read the copy to satisfy their interest. A headline on one particular billboard is a good example of this point. The headline reads, "Ever toast a friend?" and there is an image of a car on fire. You feel that you have to find out what they mean, so you read on and find it's an ad about drinking and driving. A headline with a double meaning (like this one) is a good way to get a viewer to become a reader—and a reader of a mailer is a potential client.

In a mailer that we've used in varying forms for the last six years, the headline reads, "No . . . they're not professional models!"—the copy explains that they look like they are because they came to our studios. To ensure this mailer works, we use seniors from the high school we're mailing to, with their names under their portraits. *Be sure to get a release stating you'll be using the person's name and portrait if you do this!*

Copy. This is your sales message. Mailers without copy provide no sales message, so you end up getting fewer potential clients. Not having copy (a sales message) is the equivalent of seeing your clients coming up to your studio, leaving their proofs on the front counter and then yelling, "you can just take your proofs home." Without a sales

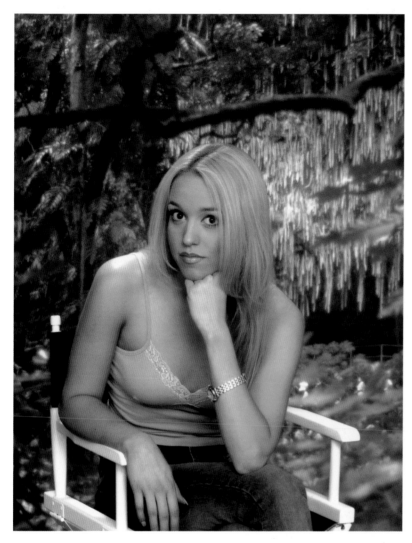

Always update the images you use in your mailers, and use photos of students from local schools. Keeping the images current will draw more clients.

presentation of any kind, you may get the proofs back, or you may not. If you get really lucky you may even get an order, but the order won't be as large as it would be with a sales presentation.

Many photographers think, "I don't know what to say. I'm a photographer, not an advertising writer." You're the perfect person for the job because no one else knows your product like you do. Advertising people have to study products before they can create advertising. They need to know what makes a product or service unique in the marketplace.

That's the keyword, *unique*. The copy tells the reader why your studio is unique and how it can benefit the potential client. Most people that write advertising list the ways in which their business is unique, but never explain why the uniqueness is a benefit. Don't ever assume that a client can figure out the benefits on their own—they shouldn't have to figure out anything. (I don't know about you, but I like making money from every client, even the clueless ones.)

If your headline reads that your studio provides lots of personal attention, be sure to spell out the particulars in the copy. For instance, spending more time with your clients is a good thing, but most clients don't know why. Your copy can explain that your clients have more clothing changes and that you take time to find out what they really want out of the session. You can also reassure them that they won't feel rushed, they'll feel more comfortable because they have time to get to know you before their session, etc. Of course, this personal attention is (hopefully) just one of many unique features that your studio

offers. Naturally, you shouldn't focus on listing too many benefits for a single unique feature if your studio has several.

In addition to "selling" your studio, your copy needs to explain what the client needs to do. If you do consultations, explain how the client can schedule one. In our case we have a consultation video, so in our copy we invite the senior to come in and take the video home. They also look through the hundreds of sample senior portraits to make sure that we offer the style of senior portraits they are looking for.

An often overlooked aspect of writing copy is this: you should always personalize the copy by using the word "you" or "your" as much as possible. When you talk about a mom, a senior or a child, the potential client doesn't automatically feel affected by what you're saying in your copy. When you say, "You'll look beautiful," "You'll feel the closeness when you look at your family portrait," "Your baby will have so much fun," you're speaking directly to the reader and will generate a personal feeling. The indirect way of writing these statements, "Our seniors look beautiful," "Family portraits that capture the closeness," and "Babies have so much fun" just won't create the same feeling. When reading these statements, the potential client get less emotionally involved with what they are reading—which is never good for sales. Remember, our product is sold by emotions, not need.

Logo. Your logo is the most important part of your mailer. If every other part of your mailer is perfect, but you forget your logo—or if your logo is hard to read—the phone won't ring. A logo doesn't have to be anything more than your studio's name set in a distinctive typestyle. Gucci commits the ultimate sin in printed advertising . . . their logos are hard to read.

Readability. This is the one word in printed advertising you should never forget. At no time should you ever compromise readability for artis-

By showing various backgrounds, and outdoor as well as studio images, you're showing the reader how diverse your studio is, and letting them know that they can come to you for unique images.

Using the same clients in different poses throughout your various mailers will help to create and help create name recognition.

tic flair. I once had a senior bring in a mailer from a local studio. He liked one of the senior portraits in the mailer, and wanted me to duplicate the pose for him in his session. I asked him what studio the mailer came from and he said he didn't know. I started looking for the studio's name. It took me several minutes to find it on the mailer.

This studio had a very ornate logo with very small type. The card was done in a reverse type (black background and white type), which is great for portraits, but really hard to read. If potential clients can't read your mailer easily, they won't read it all. Keep the typestyle clean and crisp. Reverse type or fancy background paper make reading more difficult, so make the type larger and bolder.

The headline, logo and studio name should all be prominent on your mailer. However, no type-

face on your mailer should compete with your logo. By glancing down at the mailer, your name, not just your logo, should be easy to read. If you can't see the name of your studio at a glance, make it larger, make it bolder.

Your studio name should appear at least twice, but preferably three times throughout your mailer. Many photographers think that the return address is enough to identify their studio. Remember, you can't earn name recognition if the potential client sees your studio's name once. If you only put your name on the return label and don't work it into your mailer, your readers will never take the time to find out who sent it. You have to make everything as easy as possible for the reader. The more the client reads your name, the more likely it is that it will stick in their minds.

Your studio hours should also be listed in your mailer. How many times have you gotten a piece of advertising with no hours listed on it? Then you call the company that sent the ad only to find they don't have a recording that states the hours. You have to keep calling back until you reach someone. A person might do this for a once-a-year sale, but they won't do it in an overcrowded market like portraiture. Your hours should be crystal clear. Don't list only the days and hours you're open, but also the days you're closed.

A Call to Action. This line tells the potential client what to do. Whether it reads "Call today for your appointment," "Call now, appointments are limited!" or "Call now to make sure your portraits are ready for Christmas," the call to action is the "close" of the sale. Some photographers may feel this is too pushy, too much like a used-car sales tactic. You may not care for it, but mailers with a call to action have a better response rate than those that don't. In sales terms, not including one would be like going through the sales process without asking for the sale.

Theme. The average person doesn't remember as much as we'd like to think. As I mentioned earlier, it takes four to six separate messages for the average person to remember your name and call you when they have a need for what you're selling. Your name alone will not be remembered unless you have a common theme that ties all your messages together.

Your studio name should appear at least twice, but preferably three times throughout your mailer.

This is the difference between large advertisers and independent businesses that don't know how to advertise: uneducated advertisers design their ads one piece at a time and do nothing to link those pieces together. Large advertisers work on designing a *campaign* (many advertising messages tied together with a common theme).

A common theme doesn't mean saying the exact same thing in every ad, but linking the look and feel of each advertisement together, so when the person gets the mailer their mind links the current mailer with the one they've already seen.

I see so many mailers from other studios and very few follow a common theme. One mailer is on neon paper and contains nothing but words, the next is a four-color ad with a few words and a logo, the next is a simple, newspaper-like mailer and so on. No link is made in the minds of the reader, and name recognition of your studio is not achieved.

One of the easiest ways to make a connection between your mailers is to use the same people in the mailers, with different poses. You can use the same-size mailers (don't use more than two sizes and styles of mailer) or use similar borders around the portraits and similar accents in each mailer. You can also develop an advertising slogan.

Make sure your slogan is your own! HBO is "Simply the best," and you can "Have it your way" at Burger King. Your slogan could be

"Serving the valley since 1875," "Backwoods' finest senior portraits," or "For the senior who expects the best"—slogans like these are overused, but with some thought, you can come up with a slogan that defines your studio, in as few words as possible. Once you have your slogan, put it on everything, because that will tie every piece of advertising together.

No person who takes the time to decide on a goal is without the ability to reach it.

That's it—well not really, but those are all of the components that make up the average mailer. Just about everything else is a matter of image. The type of paper you select, the borders you use around your portraits, the typestyle chosen, the images and everything else all set your studio's image for your potential clients.

Every part of your marketing plan should suit your business's image and be focused toward the segment of the market you want to attract. Your greatest marketing efforts should be directed toward the market that gives you the highest return on your time and money invested. This is the basic idea behind specialization.

Whatever choices you make, base your decisions on where you want to be and the most effective means to get you there. Specialization isn't for everyone. If you like the diversity that a general practice studio offers, look for the types of clients that bring in the most profit, the greatest satisfaction and the least time invested. Move in that direction so you have the means to enjoy life and the time to enjoy your family.

You have to define what success is to you. You can't get where you want to be if you don't know the destination you want to reach. Of this I am sure. No person who takes the time to decide on a goal is without the ability to reach it. Once you commit to a goal, you develop a passion for its completion. You become almost dissatisfied with the way things are. That outlook will help you overcome all the obstacles you are sure to face.

Increasing Profit

rofit is the primary focus of any business. Forget about your work, your talent, your portraits, your dreams—if your work doesn't generate a profit, you don't have a business, you have an expensive hobby. We all start off having a hard time making ends meet, but many photographers aren't profiting two, three, four years after they start their businesses. If you're at this point, you have two choices: make changes in your business to make it profitable or sell all your equipment, put that money into an investment account and become a waiter. Don't laugh—with tips, at least your family won't have to do without.

Since you bought this book, you probably aren't too fond of the second choice—maybe you

Profit is the primary focus of any business. If your work doesn't generate a profit, you don't have a business, you have an expensive hobby.

just have a dislike for a life of servitude. That leaves the choice of making your business profitable or, if it is profitable, making it moreso. And don't give me that stuff about, "Money doesn't matter to me!" I believe that a person who'd lie about that would lie about other things, too. It's funny how many photographers think money isn't important when it comes to buying their children a pair of Nike shoes, their wife or husband a nice home or their family a nice vacation. But you show those same photographers the newest gadget from Nikon or Hasselblad and their eyes light up. All of a sudden, money matters!

Why do you charge what you do for your work? If you can answer that question you're way ahead of most . . .

A business's profit is determined by four factors: the price you charge for your work, the price you pay for the products you need to create what you sell, the volume of work you have and controlling your spending. In photography, we tend to hear more about the price we charge than any of the other factors. Usually we're just told to raise our prices because, no matter what we charge, it isn't enough.

◆ PRICING YOUR WORK

Why do you charge what you do for your work? If you can answer that question you're way ahead of most of the people in this profession. The way most photographers set their prices is they pick up two or three price lists from local photographers. They study these prices and then price their work 5–10 percent lower than the least expensive studio. Chances are these three photographers' price lists were set in the exact same manner, so no one really knows why they are charging what they are!

If you charge $100 for an 8x10 you've obviously been doing things right, so you really don't need me to tell you how to set your prices (that is, if you actually have a base of clients paying that price for your work). Most photographers, unfortunately, aren't in this position. In fact, they're at the other end of the pricing spectrum.

Although the price you must charge is determined by many things (including lab costs, rent, payroll, etc.) there is an unofficial, somewhat standardized minimum price that you typically must charge to earn a living in portrait photography (unless your daddy owns the building you're in, and your mom is your receptionist and doesn't want to be paid).

The basic principle is an easy one. You figure all the costs to produce and deliver each portrait or portrait package if that's how you sell your work. This means everything from negative retouching to artwork, to mounting, to the presentation folders. Once you figure out the total cost of everything, multiply that amount by 3.5 to 4.5. For some photographers this seems really high, but many business advisors say that a 500% markup is about right for a decent profit in the average retail business. Now, this 3.5 to 4.5 is a starting place. Some photographers will charge much more, others a little less because of contracts, competition or lower operational costs.

If you find that your prices are lower than they should be, raise them slowly over time. Take two price increases of 15 percent rather than one jump of 30 percent. No one will notice small increases and it won't make you freak about the price you charge. If your prices are providing a substantial profit, they should be raised each year to at least keep up with inflation.

◆ CONTROLLING YOUR COSTS

We now come to the aspects of profit that are seldom discussed. The first of these are your costs. There are certain expenses that you have little control over: telephone, electricity, even rent are fixed charges that, without extreme measures, are a part of doing business (an extreme measure

Right: Why store supplies, dance backgrounds/sets and unused equipment in an expensive office space? We have an 1800-square foot warehouse for this storage and a huge savings in rent. Below: Sets are getting larger and more elaborate, and taking up more space. Many studios look for retail or office space, which is leased at a premium price. By locating our studios in office warehouse space in the nicer areas of town, we save about 40 percent in rent costs, which is important. The Fresno studio alone is over 6400 square feet in size.

would be moving to a ghetto to save on rent or buying a generator to lower the electric bill).

Cutting costs initially and comparing costs over time has to be a routine part of doing business. Two of your largest expenses—your lab's fees and the cost of your film—are also the most negotiable. Film is film. Whether you buy it from your local camera store one roll at a time or mail order it a brick at a time, the quality of a specific film doesn't change, but the price does. Mail order can save you a bundle every year, even with shipping, but when you compare mail order prices, look for the country the film was made in.

Many companies offer "gray market" film, which is produced outside the US for huge savings, but I don't like taking chances with my film. The brand of film you choose can also save you money, but most photographers, including myself, think that the quality produced by a certain brand of film is worth the added expense. For years I'd only think of shooting Kodak. I stayed with Kodak through all the changes in Vericolor, right up until the Portra series was introduced. At about this same time, my lab switched from using Kodak paper to Fuji. I saw slight color differences that drove me and my lab nuts. Finally, I was talking with the rep from another lab (who also used Fuji paper) about these color casts. He told me that for the best results, it's important to use the same brand of film as the lab uses for its

paper. I switched to Fuji film and have been very pleased ever since.

Labs are the second most common way that photographers throw good money after bad. Most photographers don't realize that many labs set their pricing structure just like photographers do. The last time we were in the market for a lab, we went to several shows and gathered price sheets: one lab had a published price of $11.60 for the processing of a roll of 220 film and thirty 4x5 proofs, while another lab had a published price of $32.00—other labs offered a range of prices between those two extremes. The one thing to keep in mind is that prices are always negotiable and the bigger fish you are, the more bait it should take to get your business.

We've compared many labs over the last seventeen years and, just like photographers, labs use

little variations in the way they present their services to try to get you to pay more for the same service. Many labs will drop spotting, blending and negative retouching from the print price so it'll appear cheaper on the price sheet. Many labs appear to be inexpensive then stick it to you on special services like artwork.

Some labs have gone to a "one price for everything" system. They price any 8x10-inch print simply as an 8x10—whether it's from a senior, wedding or family session—even though most labs have always offered lower prices on volume package printing. These same labs come up with all kinds of rebates and incentives that you can take part in. You have to realize that they aren't giving you anything, they are simply returning some of what they overcharged you.

They aren't giving you anything, they are simply returning some of what they overcharged you.

Once you narrow the field down to the best three or four labs, you have to see what each lab really charges its customers. The best way to find out the real cost and get an idea of the quality of service they offer is to get three or four negatives of an older person requiring both negative retouching and artwork (each negative should be exactly the same). The larger the smile, the more retouching it'll require. Don't forewarn the lab or explain what you're doing. Simply send a negative to each lab you're considering. Give the same directions to each lab as to the extent of artwork you want done and, so you don't spend a fortune, ask for an estimate.

We started working with one particular lab a few years back. I started to get a feeling they were overcharging us for special services. There was a 24x30-inch studio sample of a young lady that had a noticeable mustache. This lab told us it would take two-and-a-half hours for their artist to "soften" the mustache and even longer to remove it. I thought this was ridiculous, so I asked them to ship me the print the way it was. I then sent the print to another lab that we had talked to about our work. Their artist estimated it would take thirty-five minutes to remove the "stash," and they became our new lab. Our artwork bill was much reduced.

Many companies (labs included) offer special pricing to entice you and then slowly hike up their prices when they think you aren't looking. This is why you must keep comparing prices and services. Prices are important, but with a lab, the service and quality of the finished product are just as important. This is why you should have prints done from each lab you're considering. When the print comes back from each lab, you'll have a realistic idea of delivery times and printing quality. When deciding on a lab, you've got to remember that you're in business, your lab isn't your friend and Kodak isn't going to help you pay the rent when your money runs low (although many call them the Yellow Godfather). Labs are companies that provide you with a product or service for a price—and if you want to stay in business and be successful, you'd better make sure it's a good price.

Comparing prices will be a lifelong task if you're to run a profitable business. You must look at the price you're being charged for everything from folios to frames, to envelopes to your bottled water. Don't ever become involved in the good old boy way of doing business—thoughts like "I buy my film there because I like the guy!" and "I know I pay more for my cameras, but no one supports the local camera guy!" will only hurt your profit line. The only people you need to support are your family members, so buy where you get the best quality for the best price.

Comparing prices is only one area that you must look at when it comes to reducing/controlling costs. You also have to look at the way in which

you photograph. I, like most photographers, offered sessions that came with a certain number of proofs. I'd start off with that number of proofs in mind and, no matter what, the client always had twice that number of proofs to select from. The number of proofs taken seemed to correlate to my perception of how great the photographs would look. With a beautiful setting and an attractive bridal couple, family, child or senior, there was no telling how many proofs they'd have!

This was until my wife started working with me in the studio twelve years ago. She'd see a huge stack of previews and ask, "Do you realize that we have to pay for all those?" This had little impact on me because I thought it was just part of the creative process. What did have an impact on me, is when she divided a set of previews up into the different ideas that I'd photographed. There were only five different ideas (changes in background or clothing), but there were over forty proofs. That was eight photographs per idea and they all basically looked the same.

I, like most photographers, saw something good and put the camera in "machine-gun" mode. We sat down, talked and agreed that there was no need to take more than three shots of each pose: a relaxed expression, a small smile and a large smile. If I wanted to take one for the sample books or if there was a blink, I'd take a fourth shot. It was hard to get used to and I still struggle with it today, but you must realize every time the camera fires, it's a buck out of your pocket (film, processing, labor, wine to calm your nerves after getting yelled at, etc.).

The first year that I seriously tried to keep sessions close to the number of proofs a client was supposed to have, our proofing costs dropped by 20 percent. That's a whole lot of money over an entire year—money you can use to purchase new equipment, take your family on vacation, save for retirement or for your children's education.

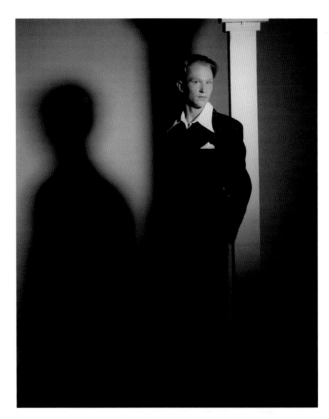

The average client changes two or three times per session and, if you don't let them do just that, you should. Variety increases sales and profit.

Your studio is going to make a certain amount of money this year, whether it's $20,000 or $1,000,000. The amount you have to show for a year's work will depend on how much you spend. Photographers that have a good business but fail to control their costs end up with a lot of money—but it changes hands, it doesn't stay in their pockets.

◆ VOLUME
When most photographers think about profit, they think in terms of raising prices and controlling costs, but the volume of clients you work with also affects profit. Most photographers spend the majority of their time waiting and traveling, with very little of their time spent photographing. This means that the average photographer must overcharge for the time they are photographing to

make up for this lost time. Don't expect clients to pay for your downtime, because they aren't stupid. It's kind of like an attorney billing a client for his time on the golf course, because he was clearing his mind to do a better job for the client. Yeah, right!

Most photographers think they must deal with clients on a completely individual basis. The client must not only be the only person being photographed, but the only client in the entire studio. Long after the client leaves, the next client comes in. This style of photographing will mean that, at most, you'll see about six clients a day—that is, *if* they all show up and you skip lunch.

In today's session, variety is key. I work with seniors, and I spend a lot of time waiting while they change outfits. The average client changes two or three times per session and, if you don't let them do just that, you should. Variety increases sales and profit. Take advantage of this fact. While your client is changing her clothes, why not photograph another client? This way, you're not just standing around lowering your profitability.

The key to working with more than one client is to have at least two dressing rooms and two camera rooms. When I talk about this with most photographers, they tell me that, with the size of their studio, they just don't have the space. Well, in many cases, photographers can divide a large dressing room. I've seen the dressing rooms in an awful lot of studios and it's no wonder why clients stay in them so long. These 12x12-foot rooms have great lighting, a huge vanity and a couch for the client's lounging convenience. Dressing rooms only need to be as large as changing rooms in a department store. Divide your large dressing room in half and start filling wasted time.

The average camera room is another source of wasted space. Most photographers design square camera rooms so they can store items on the sides of the shooting area. You need depth in a camera

room, not width. With a little rearranging, you probably have enough room in your existing space to increase your volume.

By reorganizing your schedule, you can save a lot of time and money. I, like most photographers, used to go on location with one client. While the average sale from the session was higher, it didn't offset the cost of travel. Now, we set up entire days

Above: *The one area that most photographers waste space on is dressing rooms. You're paying for every square foot of space in your building and the dressing room doesn't make you a dime. It only needs to be as large as those dressing rooms in department stores (ours are 4x4 feet). Keeping your dressing rooms small will also help keep clients moving.* **Opposite:** *On-location shots can be real money-makers. Make sure you use your time wisely—we set up entire morning and/or afternoon sessions to make traveling more cost-effective.*

(or at least an entire morning or afternoon) of sessions. This way, we still enjoy the added profit from the additional sales, but the cost and travel time required to run these sessions is divided between five to ten clients.

It's possible to provide a quality experience for your clients and still increase productivity. Although I work with up to three seniors at a time, and see up to thirty-five seniors a day, each client gets my undivided attention. While I'm working with one senior, another is changing and an assistant is setting up the background or set for the third senior. This is how doctors see so many patients in one day—and where I originally got the idea. At first I hated it, but with encouragement from my wife/business partner Charla, we kept working on ways to improve the clients' experience.

We're constantly looking for ways to build our volume. In the past, I always held consultations with each client before I photographed them. I found this increased sales because clients were better prepared and generally happier with their portraits. When our volume increased (we now reach 800 seniors) I realized that a personal consultation was no longer possible. We began to schedule group consultations. I'd spend the first two weeks of June talking with all the seniors and the rest of summer photographing them.

It's possible to provide a quality experience for your clients and still increase productivity. Although I work with up to three seniors at a time, and see up to thirty-five seniors a day, each client gets my undivided attention.

This was a start, but a few clients felt that group consultations weren't personal enough or that they'd be embarrassed to ask questions. The next logical step (since we were adding more seniors) was to create a consultation video that each client took home to view and returned on the day of their session. Many photographers want to buy a copy of our new consultation video, but it isn't for sale, since it's designed specifically for our studio.

For years, everyone talked about the importance of consulting with clients before their session, but no one ever talked about what the photographer should cover in the consultation. After being in business for seventeen years, I can honestly say that almost every problem in dealing with clients stems from a lack of information. Either you didn't know something about the client that you should have, or they didn't know something about your business (or their session) that they should have.

The easiest way to plan the things you'll need to cover during your client consultations (whether a personal meeting or video) is to sit down with your staff (which may be a lonely meeting for some of you) and list every complaint you can think of about your clients—everything from bringing in the wrong clothing to being late for their session. Then, list every complaint you or your staff has heard from clients about your studio. List every one without trying to justify any client's complaint. What you'll start to see is that a lack of information was at the root of almost every one of these problems—and that information should be included in your consultation.

If you're creating a video, the next step is to think about how to verbally and visually cover the material. Call a local video company to shoot the video and stills and you can do the voice-overs. The whole process can be expensive if you call a large production company, but many videographers that shoot weddings have the equipment necessary to produce a good product and will probably save you money.

◆ CONTROLLING YOUR SPENDING

Probably the leading cause of business failure and a lack of success in this profession is that many photographers don't live within their means. For most photographers, cameras are not tools, they're toys. These toys become our prized possessions, only to be sold off when the newer models come out, because the new model offers some obscure little improvement, which may or may not be used. I've seen photographers without a dime in savings who have no retirement fund and no health insurance for their family open a huge camera case with an arsenal of cameras and lenses.

Almost every problem in dealing with clients stems from a lack of information.

You need one camera and one backup for each shooting area you have or photographer you have working for you. You don't need multiple lenses that basically do the same job. I've seen photographers with a number of medium format telephoto lenses in different focal lengths (most that are never used) turn around and buy a zoom that covers the exact same focal lengths their other lenses cover. They are purchasing toys, not tools.

The sad thing about equipment is that when you start out, you think that a certain lens or camera will make the difference in your business—that having an arsenal of equipment will make up for what you're lacking in experience—and it won't. You can take the oldest, junkiest camera and put it into the hands of a photographer who knows what she is doing and she'll create beautiful images. You can take the most expensive camera in the world and give it to someone who lacks experience and it will produce disappointing images.

I can afford to use any camera made, but I use the Bronica 645. I feel it gives me the most value for the quality of image it produces. Many of my cameras I've purchased used—I only buy new when Bronica has a great rebate offer. This is why my wife and I drive the kind of cars we do, live where we do and why my family takes nice vacations each year. I don't live within my means, but below them.

Many photographers have the misguided notion that equipment is an investment.

Many photographers have the misguided notion that equipment is an investment. An investment grows in time. A piece of equipment, like a car, is necessary, but it's worth less and less each year, which means it's no investment.

I could easily spend over $80,000 in new, premium brand equipment for all the camera areas I have in both studios. That $80,000 of equipment will be worth $60,000 or less after just one year of use. It'll probably be worth $40,000 or less after five years of heavy use. That means your so-called investment is worth half what it originally was after only five years' use.

Now, if you wanted to be a wise businessperson, you could buy the same amount of equipment—*used*—and, instead of the most expensive brands of equipment, you could buy less expensive ones like Bronica/Mamiya/Pentax, etc. For that same equipment in like-new condition, you'd probably spend $35,000–$40,000. The value of this equipment (provided you have it serviced regularly) will decline more slowly because you aren't taking the loss that always occurs when brand-new equipment becomes used equipment. You're letting someone else (probably a photographer who rushed in and treated equipment as toys) take that loss for you.

Let's say that you have $80,000 sitting around. By saving $40,000 by purchasing used equipment and changing to a more realistically priced brand you now have your cameras and $40,000 to invest. You take that $40,000 and put it into a quality investment account, which, on average, earns about 10 percent a year and you'll earn around $4,000 per year. That's a nice vacation for your family. Of course, you can also let your interest compound, and start creating your own wealth for retirement.

If you're like the majority of those in this profession, you just laughed when I said you had $80,000 sitting around. This means that to buy that $80,000 of equipment, you must go to your local bank and ask for a loan. Now, I don't suggest you ever borrow money to buy camera equipment, unless you have to for your first camera setup. The only other time that doing so would be okay is when you have a large job that, without a certain piece of equipment, you won't be able to accept. Even then, renting would be a better option than going to a bank or using plastic.

It's become so easy to use other people's money for what we want (the bank's) that most people can't think of getting by without it. Credit has allowed all of us to live way beyond our means. Anything we want—as the sign sitting next to it reads—can be ours for only nineteen dollars a month. Strangely, people that can't afford dinner in an elegant restaurant will go anyway and put it on a credit card.

Using credit for very large purchases is a must. I don't think anyone can save up enough to pay cash for a home or automobile. Equipment is different—it can be purchased piece by piece over time. What most people who use credit to make purchases don't realize is how much it costs them. If you borrow $100,000, with today's interest rates, your payments would be about 1 percent or $1000 per month . . . for *thirty* years. That's $12,000 per year for thirty years. Realize that it'll

cost you $360,000 to pay back your $100,000. If you think this is ridiculous, look at how much purchases on high interest credit cards really cost.

Photographers justify purchases they shouldn't be making by explaining to their spouses that all the interest and payments are tax deductible, especially if you lease. Most photographers really don't have a problem with tax deductions, because what they spend is so close to what they earn. And for any of you spouses who might be reading this, the interest paid on a home loan, which is the majority of your payments for the first ten years, is also deductible from your taxes. Fifteen percent of your income is also deductible by putting it into an SEP, which is a retirement fund for the self-employed.

The funny thing about buying equipment is that when you don't have the means to make purchases and/or have little business and can hardly justify buying anything, those new toys (I mean *tools*) are most appealing. We look month after month at all the ads. We go to trade shows and drool over all the nice and shiny new toys lined up. But once we get to a point that we can afford all those new shiny toys, they lose their appeal. It's kind of like the fascination that people have with bars, right up until they turn twenty-one and the fascination is over. It was summed up by best by Spock on *Star Trek* who said, "Having isn't always as good as wanting."

Equipment will always tempt photographers to overspend, but living within one's means also requires that you look at daily habits that add up over time. I was once told, "Watch your pennies and the dollars will take care of themselves." Most people don't get into financial trouble because of a large purchase, it's usually the little ones that take all their money.

In our studio, I've had employees come up and talk with me about needing more money. They explain that they can't pay all their bills. I've even had an employee explain that I needed to buy a company truck because his car was getting older and he needed it to get back and forth to work. Now, I'm not a skinflint. We pay people a salary that's equal to or better than other similar businesses in our area.

The one thing that I noticed is that all these employees that complained about not making ends meet would come in each day with a latte from the coffee house. Each day they'd leave for lunch and go to a restaurant to eat. We had one employee who regularly complained about money, who stopped every day at a fast food restaurant for breakfast and then to the coffee house for a latte. He'd repeat the process for lunch—I should have just made out his check to Starbucks.

If you like coffee, buy an espresso machine! Make your lunch and get a life.

Small purchases, like coffee, going out to lunch, stopping by and having cocktails after work are where most people's pennies go, and why they never have dollars that take care of themselves. If you added up all the nonessential purchases most people make, you'd be amazed at how much of their income is wasted away.

People always say the reason they make purchases like these is they just don't have any time. People don't have a lack of time, they have a lack of direction. If you work an eight-hour day, as my employees do, you have sixteen hours of the day left. Figuring you sleep eight hours a day, you still have eight hours a day left over.

If you like coffee, buy an espresso machine! Make your lunch and get a life. If money is a problem, you probably aren't a high power CEO or attorney who must eat out because you work eighteen hours a day. If you are photographing eighteen hours a day, your money is well spent buying your lunch and dinner—and you probably need the coffee to help keep you awake.

Always watch the little things. In our studio (I know this sounds sexiest, but it's not) most of the ladies freeze in winter and crank up the heater to about the same temperature as the surface of the sun. Likewise, in the studio, I burn up in summer, since we live in Central California where most days are around 100 degrees. I keep inching the thermostat down until the room feels a bit like a meat locker. These little creature comforts cost the studio hundreds of dollars a month until we agreed to set the thermostats and leave them alone.

It all comes down to one simple truth: you only have so much money you're going to earn this year.

If you have employees, delete the games from your computers. I walked into my studio one afternoon and a photographer and two production workers were sitting at three different computers playing games. This is the height of productivity. Also, if you have employees, whether they are photographers or other staff members doing errands, always give them a time you expect them back. Over the years we've had employees doing everything from going to the bank for themselves, to visiting a friend, basically turning a twenty-minute errand turned into an hour-and-a-half "fiesta" that *we* were paying for.

What I'm getting at here is that with an espresso here and a wasted hour or two of employee time there, you end up living a life that's full of stress and worrying where the next latte is coming from. It all comes down to one simple truth: you only have so much money you're going to earn this year. The key is spending as little of that money as possible.

Forget about all the stupid clichés you've heard like, "You have to spend money to make money" (this one probably came from a banker or credit card company). A more precise saying would be "You must have money to make money." When you have the money in hand, it's amazing how many opportunities to make more money present themselves.

When you watch your money and spend it wisely, you'll find that you don't need to go to the bank or use a credit card for every medium-sized purchase. You'll find that your business feels like a business and not just a place where you play at your hobby. Creating beautiful photographs can be rewarding, but making a great living by selling the photographs you create is the most rewarding part of this profession.

Wealth is something I spend a great deal of time studying and thinking about. It's sad, but fascinating, that in a country that offers lots of opportunities to make money, many people live in poverty. Many people just out of high school say that the American dream is no longer attainable—but it is. People have just stopped dreaming. This is the main difference between the wealthy and the middle class/poor. Simply put, the wealthy spend a majority of their time thinking about ways to make money and the middle class and poor spend the majority of their time thinking about ways to spend money.

Money

Many people just out of high school say that the American dream is no longer attainable—but it is. People have just stopped dreaming.

This is why the poor and rich don't usually mix well. The poor or middle class say that the rich always talk about money and making money, while the rich look at the middle class/poor and say all they talk about is what they want to buy—when they don't have the money to pay for what they already have.

One day my son—who, like every ten year old, wants everything he lays his eyes on—told me he wanted to be a millionaire by the time he's in high school. I explained to him that it could be done, because anything is possible. I told him that if he really wanted to have wealth he needed to stop thinking about trading cards and toys and think of ways to earn money, that once he's made money he had to let that money make money and not spend it on toys. I only hope he listens. If he can learn to quit wanting long enough, he'll never want again.

◆ LIABILITY VS. INVESTMENT

Many people say that the desire for wealth is greed, and greed isn't good. This isn't having a love for money, however, but a respect for money.

We've recently opened a second studio. While photographing seniors is a big part of my life, and I enjoy what I do, I realize that to be successful, I need to strike a balance between my work and my personal life.

It's about being responsible and not acting like a child who wants bigger and better toys. Greed in our society has changed from a love of money to a love of toys. People shop as a pastime, not because they need something. The middle class/poor have thousands of dollars riding on credit cards for clothing that hangs in their closets—with the tags still on.

I was a child of the '80s who, once out of high school, determined that wealth meant acquiring things, not assets. All "things" are liabilities. A house, car, studio building, equipment—anything that must be maintained and doesn't generate a profit is a liability. Some of these liabilities are necessary, but somewhere down the line we all learned the term "write-off." The interest you pay on your home is a write-off, your camera equipment is a write-off and the list goes on.

The term "write-off" is the adult version of a child in a toy store saying, "It's okay, I can pick out a big toy because it's my birthday and Dad is buying." How many adults completely overspend to get a house and then say, "Oh, but it's a write-off"? How many photographers go hopelessly into debt for camera equipment and say, "Oh, but it's a write-off"?

You can never become wealthy or even obtain a comfortable lifestyle by filling your thoughts with buying "things." It would be like telling a fat person that, to lose weight, he must constantly think about food. A fat person may think of food constantly, while a thin person only thinks about food while they are hungry. Similarly, poor and middle-class people dream of big houses, fancy cars and designer clothing, while the wealthy only think about these things when they need them.

When I told my son that to become wealthy, he must spend much more time thinking of making money than spending money, his grandmother added "that's right, you have to save your money." That wasn't what I'd said, but it's an interesting difference of perspective. My inlaws are retired and very comfortable. They achieved this by working hard, watching their pennies and saving, which is something to be proud of.

◆ GETTING A LITTLE HELP

The problem with using savings alone to create wealth is that it usually takes the better part of a lifetime, and to accomplish a very comfortable lifestyle at retirement, you have to pinch every penny along the way. I don't know about you, but I don't want to wait until I'm almost at the finish line to start living it up. I don't care how much money I leave my grandchildren. What matters to me is giving my wife what she truly deserves, my children the best childhood they can have, while planning not to be a burden to anyone later in my life. This means I have to do more than most people are willing to do to achieve as much as I can in the shortest amount of time. This means I have to look for ways to do the things that I want and need to do, while taking full advantage of any and all legal tax breaks and incentives. In the profession I've chosen, this means I must use the talents of other people, and must profit from their skills.

You won't become wealthy or even obtain a comfortable lifestyle by filling your thoughts with buying things.

While I was writing this book, we opened a second studio near Monterey, California. Since the studio is new, I'm there each week. Charla and I are working seven days a week. Our children travel back and forth with us each week—we've made them a play area in the studio so they can be with us. After this studio is up and running, we're planning to open another. It's a great deal of work, but I want to enjoy life now and still save for the future.

Another important part of living well is to have an accountant who knows the tax laws and can give you advice about obtaining things that you

While artistry is important, so is the bottom line. Money is a vehicle for making more money. When you're financially comfortable, you can concentrate on making great portraits, instead of churning out low-quality images just to make ends meet.

want or need while legally taking them as a deduction. A good example is some of the trips we take. We have a front projection system in both studios, which are used to create great backgrounds from our slide collections. Seniors can select backgrounds from Tahiti, Cancun, St. John's, Europe, Asia and just about anywhere else in the world. Since we use these slides as backgrounds, a portion of all the travel expenses are tax deductible. Needless to say, this creative option also sets our studio apart.

In a book on taxation, the author talked about dealing with the dilemma of finding and paying for a place for his son to live while he went to an

out-of-town university. The author decided to buy a home that had been divided into small apartments, close to his son's campus. He then hired his son as the manager of the apartments. When it was all said and done, he had a place to live, the rent from the tenants covered his small salary and the monthly mortgage payment. When his son graduated, he sold the building for a modest profit. Now *that's* a great example of finding legal and ethical ways to be able to get what you want or need.

Money is a vehicle that makes making more money possible. I don't have a love for money, I have a respect for it. Money equates to freedom. Freedom to live without worry where your next dollar is coming from. Freedom to see a little of this world before your number is up—and a freedom to survive if something happens and you are unable to do what you do now. This isn't greed, this is responsibility.

Your Greatest Commodity

What's your single greatest commodity? Is it money? Most people think so, but to successful people, the greatest—and most limited—commodity a person has is time. Now, I'm not talking about how everyone professes they just don't have time to do what they want. Again, most people don't lack time, they lack direction. I have younger people who work for me less than forty hours a week, sleep twelve hours a day, watch TV and play video/computer games fours hours a day and yet complain they don't have time to take care of their personal business. They need to take time off from work to get their personal business done and, with a fast-paced schedule like that, you can understand why. After all, I'd hate for them to get only eight hours of sleep or give up a few hours on the Internet.

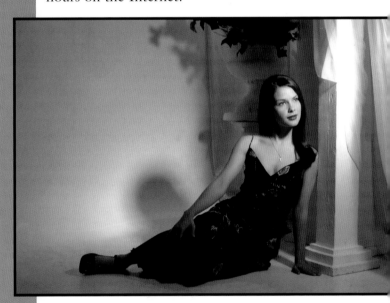

For photographers, time is especially important. You only have so much time in the week to photograph and, realistically, there is only so much you can charge for your work. This means when you reach your limit, your income will stay at that point for the rest of your life—unless you start using the talents of other people to make your money for you.

◆ MAXIMIZING TIME

Everyone thinks they don't have enough time, but most people just don't use their time wisely. To a successful person, time is the first limiting factor to further success. You get so busy making money that you don't have time to manage it, to say nothing of looking for and pursuing other opportunities to make more money.

For photographers, time is especially important. You only have so much time in the week to photograph and, realistically, there is only so much you can charge for your work. This means when you reach your limit, your income will stay at that point for the rest of your life—unless you start using the talents of other people to make your money for you.

◆ EMPLOYEES

Every business owner needs to rely upon the work of others in order to become something more than the typical mom-and-pop shop. This is a hard hurdle to cross for many photographers, including myself. When my wife and I talked about adding additional schools, we both realized that we were maxed out. I couldn't photograph any more seniors in the months of June to September. The only way to contract more high schools was to bring on an additional photographer.

Being blessed with a healthy ego, which most photographers have, I explained to my wife that no one could take images that would compare with mine. It would take years to train someone to do what I do and no one would work for what we could afford to pay. In addition to the concern about payment was the worry about training future competition. It used to be that people had

What's your single greatest commodity? Is it money? Most people think so, but to successful people, the greatest—and most limited—commodity a person has is time.

some degree of character and wouldn't think of causing harm to the person or business that gave them their training. Nowadays, it's a dog-eat-dog world and people have no problem using your training against you.

I finally hired a single photographer to take the yearbook portion of each session, and we now have seven photographers that work in different capacities in the two studios. When you train photographers, you have to use common sense about the amount of training you'll provide and

A photographer needs to gain a lot of experience before he or she can shoot images like these. When you train new photographers, take it slow. When you grow to trust them, and they've proven their worth to your studio, you can share more of your technique—but be selective!

how quickly you'll give them each piece of the puzzle.

Let me explain what I mean. When we hire a new photographer, he starts out as a yearbook photographer. He is taught three to five poses, and slight adjustments to the lighting and camera operation. That's it. He is a button pusher that concentrates on expression. When yearbooks are over, he shoots sports for our schools. After the first year, he's trained to pose clients and get the sets ready for the photographer. The third year he starts to photograph sessions, but I or one of the other trained photographers have to check each shot before it's taken.

We tend to train people in two ways. Creative people are taught how to pose, check for details and compose portraits, but know very little about

the actual lighting and other technical aspects of photography. Photographers that have technical experience set up the lighting, do the metering and operate the cameras, with someone else taking care of the posing and set design.

My young photographers and set movers are always with me during test sessions. They always come up with ideas. Some of them are good, and others need a little help to become good ideas. I'll use any idea that will benefit my clients.

No photographer is taught the operational side of the studio or deals with the administration at our high schools. Don't teach too much to any one person—and if you think this sounds paranoid, you're wrong. Every two to three years we hear of another photographer going out on his or her own and taking a school or two with them from the studio that once employed them.

The same is true for other types of clients as well. Let's say you specialize in children. You hire a young photographer who learns your creative and business practices. After a few years she decides she wants to go out on her own. She wants to make it, but the only experience she has is what you've taught her. Her choices are (1) starve or (2) use your training against you. What do you think most photographers would choose?

When you hire a photographer, your goal should be to train her thoroughly in each aspect of his job, over time. The longer a person stays with your company, the more loyalty she has—and the greater her value to your business. By the time she is fully trained, she's become pretty valuable to your business—and you can pay her a competitive salary.

When you start to train a photographer, the first thing she must understand is that her job is to recreate your style of portraiture, not experiment on your paying clients. This isn't photo class at the community center. Many times, it's easier to train a photographer that has less experience and a good eye for detail than it is a photographer with more experience. Old habits are hard to break, and a person who has less experience is a clean slate that you get to mold and shape into your way of doing things.

Creative people help me more than technical people. Again, I mainly need technical people to set up the lighting. Once that's done, I need creative people with a good eye for details to work with the clients. This isn't commercial photogra-

phy, which requires a great deal of technical knowledge. The lights go where they go and are adjusted to suit each person's facial structure. It ain't rocket science. A pleasant person who can spot stray hairs, bra straps and wrinkles in clothing —and make people smile—is about all I need.

Young creative people can also help you to become a better photographer . . . if you let them. I've seen many photographers work with their young assistants. Every idea that the assistant comes up with (whether it's good or not) is shot down. While this may make the older photographer feel superior, it doesn't let you take advantage of a different perspective and someone else's talent.

My young photographers and set movers are always working with me during test sessions. They always come up with ideas. Some of them are good ideas and others are ideas that need a little help to become good ideas. I'll use any idea that will benefit my clients—whether it's theirs or mine. These young employees are also great to run *my* new ideas by. They're much closer to my target audience's age than I am. If you can learn to put your ego aside, young employees can be a gold mine.

I'll be the first to admit that dealing with employees is a major pain in the neck. You have to deal with their moods swings, the affect that their personal life has on the way they do their jobs, as well as the general feeling that no matter how much you pay them, it's never enough. And, at just about the time you want to pull out your hair, you have to remind yourself that you can't do it without them.

With trained employees, I can be at one studio while the other studio is operational without me. When we get to a point that two studios can run without me, we'll open a third (maybe . . . maybe open a restaurant . . . maybe retire!). Without employees, this wouldn't be possible.

To me, maximizing time and utilizing trusted employees is success, but it might not be for you. You may want to be in control of the outcome of each session. Even so, you can still conserve your time by using the talent of others. If you work as the sole photographer, hire a person to move your sets and have each pose ready for you to take. This allows you to work with more than one person at a time and increase your profit. Doctors use nurses and assistants to increase the number of patients they see, why can't you?

Many photographers starting out think they can't afford the high wages of talented people. They don't understand how inexpensive talent is. I get e-mails from young photographers all over the country who want to work at one of our studios. Many of them say they'd work for minimum wage, just to get the experience. If time is our greatest commodity, talent is the cheapest. Talent is easy to find and, in a competitive market, it's a very inexpensive commodity for someone who has more money to spend than time to manage it.

Managing time doesn't mean you have to set your watch alarm to go off every fifteen minutes.

Managing time doesn't mean you have to become some kind of freak that sets your watch alarm to go off every fifteen minutes. You don't have to plan every second of your life. It means you have to use the talents of others to accomplish more in less time.

Like most studios, we work with complex software that comes with manuals that are as thick as a bible and all written in computer geek. We design all our own mailers, maintain and upgrade our web site (www.jeffsmithphoto.com), as well as all the programs necessary for digitally capturing images from sessions—and we get help when we need it. Using new software can be complicated: you have software that takes the image from cap-

ture to viewing, from viewing to correction, from correction to packaging and from packaging to storage. On top of that are the upgrades that come around every year for each and every program.

This is way too much reading for a business-person like me, who wants to have a life outside of the studio. In the studio we always have computer people who read the manuals for us, figure out the software and then explain it to me. We aren't talking about computer techs who charge forty-five to seventy-five dollars an hour. We're talking about computer literate men and women in or just out of high school. They work for the experience and a little more than minimum wage.

To be successful, you have to find the shortest route to getting what you need.

Your lab can also help save your most limited resource, time. When we decided to branch into digital, we had our lab send their computer person to the studio to help get us started. He spent an entire day going over the whole process of digital, from calibrating the monitors to going over all the software. He captured, viewed, corrected, packaged and stored the digital images. It would have taken me months to figure out what he taught me in a day, or I could have paid a consultant thousands of dollars for the same information.

To be successful, you have to find the shortest route to getting what you need. Many times, the path we take to save time through technology ends up taking more of our most valuable commodity. I can't count the number of times an employee needed information on a particular product. She'd find a phone number and a web site address somewhere on the package and, to save me the long distance charges (and getting the needed information in three minutes on the phone), she'd go to the company's web site. An hour later she was still looking for the information. That's penny wise and pound foolish.

To make a profit in this business, you need to look at cost in terms of not just money but time. If any product or service that you offer your clients is going to take additional time, make sure someone else (an employee) can provide the time and then make sure that your clients value the product or service enough to pay more for it. If not, introducing the product or service would be taking a step backward, not forward.

uccess in a portrait studio requires two seem-
ingly opposite tasks: making a great living and
being creative, yet remaining in touch with what
your clients want. While many photographers have
one, few have managed to accomplish both. Many
studios never enjoy the financial rewards that are
possible, so the owner gets tired of living in pover-
ty and chooses a new profession. On the flip side
are the photographers who do achieve a certain
level of success financially, only to feel as though
they are running a photo mill, herding people in
and out just for the sake of making money.

I love photography almost as much as I love all
the things that making a good living allows me to
do for my family, friends and, of course, myself.
For many photographers, making a tremendous
amount of money by selling their art feels like sell-
ing out.

The first hurdle for most photographers to
overcome is to understand just who they are cre-

Creativity

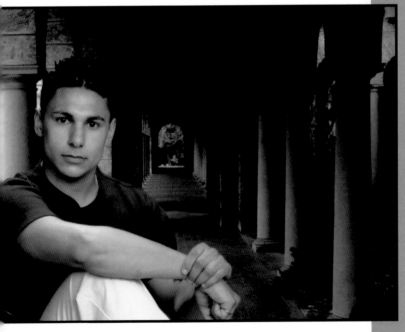

*Success in a portrait studio requires two seemingly
opposite tasks: making a great living and remain-
ing creative, yet in touch with what your clients
want.*

69

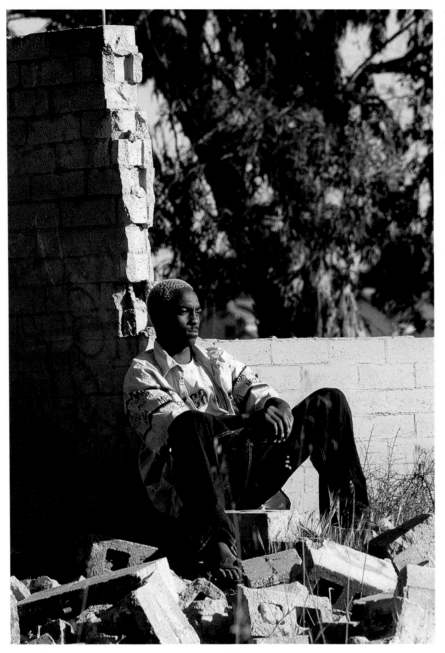

If you're creating images for yourself, you'll never be successful in this profession. Many photographers take every image in every session to meet the self-imposed standards without thinking of the person who's hired them.

We have photographers in our area who refuse to take photographs in a certain way because it doesn't fit in with the style of portraits they prefer.

I love telling the story of a young man who came into my studio ten or eleven years ago. He was on the yearbook staff of one of my contracted high schools, so he knew me fairly well. When he came to his session, he explained that his grandfather was a senior photographer in our area. I immediately asked him why he wasn't going to be photographed by his grandfather. He told me that both he and his father wanted photographs that reflected more of his personality (in casual clothing, leather jacket, with his football uniform, etc.). He said his grandfather refused to take portraits like this because these weren't *traditional* senior portraits.

This is an interesting outlook for a person in a creative profession—especially for one involved in one of the most competitive areas of professional photography. Unfortunately, many older photographers refuse to roll with the changes. They've taken a certain path and have managed to overcome the odds and survive through the years, and changing paths or keeping up with the market they are serving becomes unthinkable.

This problem is reenforced by the typical means of measuring creativity, which is print judging. A print is judged by the merits of the image accord-

ating their images for. If you're creating images for yourself, you'll never be successful in this profession. Many photographers take every image in every session to meet the self-imposed standards *without* thinking of the person who's hired them.

ing to another photographer, not the people who'll be buying the final work. This would be like Ford asking Chevy about its car designs. Ford doesn't care what Chevy thinks, they care what the car buyer thinks, because Chevy could be as far off the mark as they are.

Seminars and programs designed to help professional photographers also contribute to the "photographer knows best" way of thinking. These programs are designed to excite photographers. Most photographers putting on programs show off their ideas. Most are very creative, but some of the ideas have little or no business merit, because they will not sell to clients. I've always loved the expression, "Well, I don't sell many of these, but . . . !" If you don't sell a particular type of image, what's the point in taking it?

Here is a partial list of some of the ideas I've seen at programs—ideas that, at the time, I thought were great—and how my clients responded to them.

- Extreme wide-angle outdoor portraits: "He's so far away that I can't see his face" or "If I wanted a picture of all that greenery, I'd have told you so."
- Using a projection box and projecting a pattern over the client: "Why is there a shadow over my son" or "You end up looking at the pattern and not the person."
- Senior girls in swimwear, push-ups, low-cut tops, etc.: "I don't want my daughter looking like a hooker" or "Cheesecake of seventeen-year-old girls, isn't that illegal?"
- Offering makeup and hairstyling in your studio: "She doesn't look like herself" or "All of the girls look the same." (Makeup artists, like photographers, have a specific style and give each client a similar look).

The clients' reactions to these ideas were not positive, but I did try them. I never presume that I know what my clients will want, so I offer everything and let my clients decide what's right for them. However, most of these ideas turned out to be more exciting to photographers than to clients.

Many of the newer products, like watercolors, transfers and other high-ticket items work out the same way—they're nice to look at but you won't sell many. In order to offer these products, you have to reduce your profit margin, which usually

I never presume that I know what my clients will want, so I offer everything and let my clients decide what's right for them.

ends up cutting into a client's order. There are four factors to keep in mind when looking at any new idea: (1) Don't presume something won't work until you offer it to your clients. (2) If you must reduce your profit or spend a great deal of time/money to create or buy something, but can't get away with charging a normal markup, it's best not to take the risk. (3) If you don't feel morally comfortable offering a certain type of portrait (swimwear to seniors, etc.), *don't* do it, no matter what anyone says. (4) Finally, if a photographer accepts money or products for sponsorship, question their every word about those products manufactured by the companies they're sponsored by. In my many years of going to programs, I've heard a speaker give the most moving speech about Kodak products, only to hear them give the same speech about Fuji the next year. Some photographers stand up in front of God and everybody and say "This digital camera is only $12,000" or "That digital back is only $20,000." You know that if that speaker had to pay for those items they wouldn't be using the word "only," they'd be begging a banker to give them a loan.

Another roadblock to achieving a balance between money and creativity in many photographers' careers is what I call the photo school philosophy, the thinking that to be truly artistic as a photographer you must spend hours planning, pondering and then finally taking the portraits. Some of my photographers were a product of our local college's photography program. Most were like a deer in headlights when it came to working in the real world. Most if not all of them were constantly complaining about having to work within a time frame, and they put more stock in their jun-

It is possible to photograph a session of any client and have most if not all of their session made up of outstanding images. Combining great technique and some unique ideas can work wonders.

ior college professor than successful working pros like Don Blair, Larry Peters and the like.

◆ CREATIVITY ON A LARGE SCALE

This isn't rocket science. Any photographer with a certain level of knowledge and the right circumstances can create an outstanding image. What you must work to achieve is creativity—on a large scale. It is possible to photograph a session of *any* client and have most if not all of their session made up of outstanding images. When I say anyone, I mean anyone.

In my book, *Corrective Lighting and Posing Techniques for Portrait Photographers* (Amherst Media), I show the many ways in which you can alter a person's appearance in a positive way by just learning to fool the camera. You cannot learn to photograph the buying public and make them look their best by spending your time photographing super model–types in test sessions. Some men and women are so beautiful all you really have to do is get that face on film and it's a beautiful image. These are the people that the average photographer asks to come in for test sessions. These are the people most photographers use in the prints they send in to be judged. This is what I call the right circumstances.

To be creative over the long haul, you have to challenge yourself to grow beyond what you know today, every day. Every year as summer approaches, each of my staff members, from the receptionists to the photographers, look at the upcoming months with dread. There is only one person who gets truly excited—me! I've been doing this for eighteen years and although I'll have to work harder than anyone else in my studio (I see over 3000 seniors throughout the summer), I'm like a kid in a candy store. The kind of activity we see in the four months of summer is something I've dreamed of my entire life and the other eight months I get to enjoy the fruits of my labor.

Over the years, while many photographers in my area have come and gone, certain things have helped me retain my zest for what I do. My first exercise to keep myself creative is writing. The writing aspect of the books and articles came easy to me. I love to talk and I write the way I talk, so people say that my books are easy to understand. The part of writing that keeps me growing is having to illustrate the books, to have to think of ways to take images and overviews that explain what I'm writing about. And—talk about pressure—realizing that my books are going to be sold to some of the best photographers in the country really keeps me going. These photographers will be critiquing every single aspect of every image. I can honestly say that by the time I've finished the months of work it takes to write and illustrate a book, I'm a much better photographer for it.

Creativity isn't about what you know, it's about what you don't know and your desire to learn.

Now, I realize that not everyone that reads this book can write a book. While you might not want to commit months of your life to writing a book, when the chances of being published aren't in your favor, there's another route. Articles for magazines take much less time to write and have a greater chance of being published. Even if they don't get published, you'll find the rewards coming out in your work.

Look for situations that force you to push yourself beyond your current limits. Whether you have five backgrounds or 500, when it comes to illustrating an article you'll look for new ways to use what you have. You'll try things you've never tried before, because your work will be in the spotlight. Between the pressure to produce and the desire to create your very best, you'll become a better photographer.

Creativity isn't about what you know, it's about what you don't know and your desire to learn. Anyone in photography who thinks they've learned it all has lost his creative edge. No one knows it all, for the perfect images have not yet been taken . . . and never will be. Why? Because what's good today won't hold a candle to what will be created

Putting every pose and background you offer in a sample book—letting them see their options—will help the client take responsibility for the outcome of the session.

tomorrow. The bar is always being raised and you can let fear of falling behind consume you to the point of giving up or you can decide to be one of the few that keep raising the bar.

Let me make one thing clear: creativity has to do with your mind, not a piece of equipment or a new program. Creativity is about putting perfection on film (or the chip)—repeatedly. This has nothing to do with gimmicks, technology or equipment. When it comes to my own creativity, I'm no more impressed with what can be done in Photoshop than in what the artist at our lab can do to enhance a print. Both have nothing to do with me. I'm a photographer, not a computer technician or a print retoucher, and if I do my job well I won't need to use the services of either one.

Photographers must raise their standards, based on their client's expectations, in order to be successful—both creatively and financially. The first step to doing this is to find out what your clients want. The easiest way to do this is to put every pose and background you currently offer into sample books. Before the start of any session, each client should be asked to look through the books and select the poses and backgrounds they want done in their session.

Many photographers at this point say, "Hey, I'm the photographer, I know what they should have." No, you don't! Clients are individuals and to keep them happy you need to treat them as such. Besides, allowing a client to select her own poses or backgrounds doesn't always mean that those are the exact ideas you're going to use. It just means that you have a starting point. In the session, you can take her basic ideas and make suggestions as to other poses and backgrounds that might be better suited to her. Just make sure these suggestions are based on her preferences and not your own.

Many photographers think they know what their clients want and need. Remember that clients are individuals and, to keep them happy, you need to treat them as such. Besides, allowing a client to select her own poses or backgrounds doesn't always mean that those are the exact ideas you're going to use.

If you have the client select her own background, you'll accomplish many things. First, you'll improve your profit, because your client will get exactly what she wants. Second, by allowing her to choose her own background, you also hand over part of the responsibility for the outcome of the session. How many times a week do you hear, "I really don't like that pose," or "Why did you pick that background?" A photographer's ego takes a beating handling questions like this, but when the client has selected her own backgrounds and poses, how can she complain?

The second thing that we do is ask clients to bring in any photographs that impress them. This will give a better idea of the client's tastes and what they are looking for. About half of our senior girls will do this. We ask that they tear pictures out of magazines, rather then bringing in the entire magazine. This way, we can keep the picture after the session is over. These clippings become an important part of offering

We routinely ask our clients to bring in images from magazines that appeal to them. With these images, we can get a pretty good idea of what it is that appeals to them.

our clients the style of portraits they are looking for.

Remember, these are images that are hand selected by your target market. You don't need to ask other photographers for direction, you can go to the source.

◆ THE TEST SESSION

I think that all photographers (except those post-prime cameramen who know all there is to know about photography) do test sessions. Test sessions are one of the most important parts of staying creative, provided they're done correctly. The biggest mistake that most photographers make is that they don't plan test sessions. They see a handsome guy or beautiful woman and ask them to do portraits. They come in and each attractive client ends up with the same poses and the same backgrounds.

Most photographers set themselves up for disappointment by asking a person who looks like a super model to do a test session. You'll never grow if you keep photographing perfect people. Any photographer in the country with a basic understanding of lighting can make a person like this look good. And the most frustrating part of photographing perfect people is that your clients are far from perfect. The lighting and posing you tried on Mr. or Ms. Perfect in the test session takes on a completely different look when you try it out on Mr. John Doe and Ms. Jenny Q. Public.

Any person you ask in to photograph for a test session should have at least one serious flaw. It may be their weight, nose, ears—whatever!—but they must have something wrong. Your goal is to not only make this person look beautiful, but to hide or disguise the problem in every frame.

Another mistake that photographers make in test sessions is they shoot way too much film.

Try out new ideas—with "real" people, not super-models—in your test sessions.

Again, you are setting yourself up to fail. You shoot 200 frames of film for a test session, then you go into a session with six changes and hope to provide your clients with twenty great photographs. Either it won't happen, or it'll seem very frustrating and limiting.

If you usually shoot three frames per background or clothing change, then that's what you need to shoot in a test session. I don't care how many ideas you try during the test session, but only shoot the same number of frames as you publish in your session price list. The idea behind the test session is to practice what you do. What you do is offer a certain number of previews to a client. A test session isn't a trip back to photo class where you could take 200 frames to produce three great ones.

When running a test session, try out new poses and background ideas.

When planning a test session, you should also come up with new posing and background ideas. Most photographers start a test session with one or two new ideas in mind and then spend the next hour and a half doing the same old stuff that's in their sample books. When we schedule a test session, I pull out all the clippings that clients have brought in, combined with those clippings that I and my photographers have torn out of magazines like *Glamour, Cosmopolitan, Seventeen,* etc. These become the poses and backgrounds we use in the test session.

I realize that many of the clippings are going to have backgrounds that you don't have, but that's where creativity comes in. It forces you to take what you have and create something that looks similar to what you see in the clipping. Improvisation forces you to exercise your options. It forces you to think, it forces you to create.

The same ideas are used for test sessions taken at outdoor locations. Many photographers keep going back to their favorite tree or familiar spots. That really doesn't inspire creativity. When you take a test session client to a location, don't use one familiar spot or pose. Take your clippings for new posing ideas and search out new and interesting spots to use.

Staying creative requires that you not only try new and interesting ideas but also that you know

when to give up the ghost of the old ideas that are no longer in sync with your clients' expectations. Usually, a creative photographer will get tired of familiar poses and backgrounds way before clients tire of them. We have a set that I made back in the days of '80s boudoir. Gathered pieces of satin are used as the main background. There's a mosquito net that drapes around two columns, and we place everything from a plain white column to a wicker chair to a swing between the columns.

Over the years, we've updated this set to keep it current, but the basic setup has remained similar. Every year, it's one of our most requested sets. Quite frankly, I'm sick of it, but I'm not creating portraits for me, I'm creating them for the client. If twenty years from now clients still request the newest version of this set I will happily do it for them. However, if this background ever loses its appeal, I will be happy to remove it from the studio.

More than anything else, a positive outlook will keep you creative. You'll achieve what you expect to achieve. You'll be as good a photographer as you expect to be. You'll be as successful as you can see yourself being and you'll continue to grow until the day you no longer expect to.

As I was growing up, my father had an expression that I've plagiarized every time I've put on a program or written a book—but hey, he was my dad, so it's okay. He used to tell me, "As long as a man thinks of himself as green, he is growing. It's only when he considers himself grown that he begins to die." There is a great truth in those words, a truth that can bring you success and enjoyment or bring you a life of mediocrity. The choice is yours.

Staying creative requires that you not only try new and interesting ideas, but also that you know when to give up the ghost of the old ideas that are no longer in sync with your clients' expectations.

Digital Photography

The profession of photography is changing— or is it? We still use a piece of equipment to capture an image of a client that (we hope) they will like. They place orders for prints of that image, which we own the copyright to. They pay us money, we pay our bills and, hopefully, we have a big pile of money left over every month to invest.

When you think of the new technology in those terms, it really doesn't seem like a big deal. Many photographers think that this is a scary time, but the pressure that many photographers feel about changing to digital is unfounded. A camera records an image. Whether the image is created on film or a computer disk, who cares?

The real issue isn't the way in which you record a session, but the reason why you have chosen to record it that way. Have you refused to try digital

Once you start working with digital, you'll see why so many photographers get so emotional about it. It's fun!

due to fear of something new? Are you afraid of being left behind or of learning something new? Is it *change* that bothers you? Change challenges us and, as human beings, we're at our best when we're challenged the most. Whether your choice is film or digital, make sure that your decision is based on logical business sense and not emotion (fear/fascination). If you do that, your decision will be the correct one.

◆ CONFRONTING CHANGE

The progression to digital was put into perspective for me during a dinner at a senior convention. We were sitting at a table with some of the photographers who'd given programs during the convention. There was one family who'd been in business for years. They were into their third generation. Their son, who was my age, had gone into digital. As the photographers around the table were talking about digital, the father, who was in his sixties, remembered the shift from black and white to color film. He told us that some photographers saw opportunity, some photographers were scared to death and some said it was just a passing phase and that images *should* be captured in black and white.

This is the same reaction that photographers are having to digital today. Some are scared, some refuse to think about it, but I promise you this: it is *not* a passing phase. Once you start working with digital, you'll see why so many photographers get so emotional about it. It's fun! Beyond that are all the ways to incorporate graphics and special effects into photographs—there's no film and no chemicals, and you get instant proofing. I'm sure that eventually every photographer will switch to digital, but it'll take some time.

More important than how you create a portrait is the way in which you handle change. Change happens no matter what profession you're in. Change never happens as quickly as it is projected (obviously, because we didn't incinerate in a nuclear holocaust or have a social meltdown with the new millennium—and I'm still waiting for those flying cars that we're supposed to have by now!). However, the one thing everyone can count on is that human beings hate change. Change, however painful, makes us stronger. People become successful not by feeling settled, but when they are challenged. Change creates challenge. It forces us to become more than what we are.

More important than how you create a portrait is the way in which you handle change.

If you've decided that digital isn't for you right now, and you've based this on profit, that's fine. But if you've decided that digital will never be right for you, you have a problem. Photographers that refuse to consider digital are the same photographers who refuse to use a computer for their invoicing, despite the fact that it'll save time. These are the same people whose photographic style doesn't change much over the years or even decades.

Many photographers suffer from fear of change. In most cities you see studios that time forgot. They have 1970s décor and a general feel that Barnaby Jones should be walking out. Even though most businesses left the area, these business owners don't want to pay more for rent (or their building is finally paid for . . . who cares if there are hookers walking back and forth in front of their building!). They are scared to leave what's familiar.

It is easy for people to keep doing exactly what they've always done but, to be successful, you can't. You have to take new opportunities. When there is a new way of doing things, you have to take advantage of it, *if* it allows you to provide a better product or more convenient service for your client. Whether it is color film over black and

white, offering your clients new ideas, moving to a new studio (or renovating the old one) or capturing an image digitally, successful people learn not to fear change, but to see opportunity in it.

◆ DIGITAL AND THE OUTSIDE WORLD

I'd call myself a digital realist. In my quest to learn as much as I could about digital, I found that the people who kept telling me I should go digital stood to make money on my decision. My lab told me to go digital because they could make money—and they'd have almost no work to do. I'd retouch the image, color correct it and then

Successful people learn not to fear change, but to see opportunity in it.

package it. All they would have to do is pop in a CD and hit print—no testing, no negative retouching, no carding, no wasted paper. Of course they wanted me to go digital! As large as my studios are they should've bought me the cameras.

In talking with photographers about digital, I found that most were either sponsored by a digital company, selling digital products or were still suffering from the digital glow. Anyway, I realized that if I was going to make an educated decision, I needed to see for myself whether I was ready for digital—or to more properly put it, if digital was ready for me.

◆ GOING DIGITAL OUR OWN WAY

About four years ago, my lab told me that anyone who wasn't using digital with seniors would be out of business in five years. Like most photographers, I got a little concerned. I thought it was time to look into the cameras and backs that were being offered. I called around and, at that time, the largest size image any 35mm-style digital camera could print was 8x10 inches. I was told I needed a $15,000 digital back to produce anything larger with photographic quality. This "wonder back" would allow me to print out images up to 11x14 inches in size. I explained to the salesperson that we sell many 16x20- and 20x24-inch prints. They had a back for $25,000 that could produce up to a 16x20-inch print, but nothing that would produce a 20x24-inch image (remember, this was four years ago!). I'd need five digital backs for all of my shooting areas and photographers. That's $125,000! At that point, I realized that it might be more than five years before all senior photographers had gone digital.

I've written many articles about digital and most of them aren't positive. It's not because I oppose digital, but because I dislike the way that most photographers use this new medium. Most

photographers go into digital for emotional—not business—reasons. Shooting digital is fun, there's no doubt about it. You're shooting with a 35mm camera that's easy to work with. You see what you create immediately and there are all kinds of special effects that can be applied to your images. Those are the reasons why most photographers go digital, but none of these are based on business sense, just the emotional attachments of a creative person.

Many photographers feel that if they don't jump on board quickly, they'll be left behind—and they're wrong. Actually, the longer someone waits to convert to a new technology, the easier the

Don't go digital just because you think everyone else is doing it. Going digital can be very expensive, and can be detrimental to your business if you take the leap before you have a solid business plan in place.

By waiting long enough, you can learn from the mistakes of others rather than making them yourself. What the computer person from my lab taught me in one day would've taken me months of trial and error to learn on my own.

transition is. The equipment, software and knowledge of those who are involved with digital is so much greater than it was just a few years ago. By waiting, you let others pay more for their equipment and fund the research for the new versions that the intelligent users will buy. They also struggle to come up with ways to make everything work. By waiting long enough, you can learn from the mistakes of others rather than making them all yourself, preserving your most valuable asset—time. What the computer person from my lab taught me in one day would've taken me months of trial and error to learn on my own.

Use sound business principles rather than emotions to decide what's right for you. There are many people that went completely digital years ago and have made a great deal of money using new technology to provide options that were impossible with film. Although their equipment costs were high, they increased their profit. Again, this is simply a sound business decision.

I know it's tempting to buy into the hype that everyone will be shooting digital in five years, and you'll fall behind. Well, that's what they were saying five years ago. Ten years from now, Kodak and Fuji will still be producing film, and labs will still be around to print it. When I hear statements like this, I think back to the predictions made when I was a kid. I keep looking for those flying cars that were supposed to be available by now and the massive unemployment that computers were supposed to bring as they replaced human's jobs, but I just can't find them.

Use technology when it makes business sense and not one second before. If you can get the information you need from a toll free number faster than the Internet, pick up the phone. If your cameras are paid for, your appointment books are full and you don't see a way to pay for the additional cost of digital, you'd be a fool to change at this point. While many see digital as a creative tool, a few look at digital as a way to make their business grow and to make the most of their money and time.

◆ IMAGE QUALITY

Since I wasn't going to turn to the bank to finance digital equipment, I knew I had to wait until digital camera prices were about the same as film camera prices. With the introduction of the Canon D30, I thought the time might be getting closer.

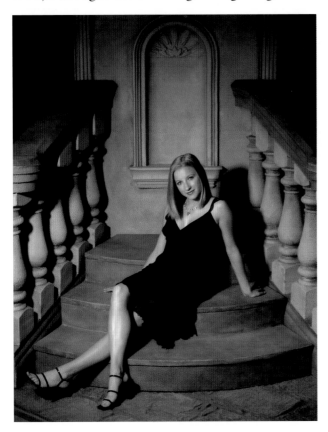

Digital is just another means to creating great photography.

I asked the lab about the largest size I could print from a D30 file. They told me they were printing 16x20-inch prints that looked as good as film. Since we specialize in seniors, who typically don't need images larger than 16x20 inches in size, I figured it might work.

Because my lab stood to make a bigger profit if I went digital, I wanted to see the results for myself. At a trade show, I found a company that rented the D30 on a weekly basis. I think it was around $200. This sounds like a great deal of money for a week, but compared to purchasing a $3000 camera that might not work for us, it was cheap.

I got the rental in. We did test sessions for two days with the camera. We did everything we normally do in a session to see for ourselves how the camera performed. We then sent the files, as they were taken, to our lab. Two weeks later the images came back and I was amazed. Even the 16x20-inch prints looked great. The paper had the exact same look and feel as the paper for film. It was everything the lab said it was.

The one thing that confused me was how a 9MB file could produce a 16x20-inch image. The chip that captures the image in a digital camera has individual characteristics and qualities just like film. Although two different camera brands may produce a file of the same size, the quality of the image and the degree it can be enlarged can be different. From what I've seen, the CMOS chip used in the Canon seems to produce a higher quality image than the CCD chip in some of the competition's cameras.

Technology passed the first test. The camera performed well and was priced in line with medium format film cameras, so I wouldn't have to take out a loan to buy it. The fact that we used 35mm Canon cameras to shoot candids for our schools was an added plus since our lenses could also be used with the D30.

At this point, most photographers would've jumped in with both feet, but I'm not most photographers. A camera is just a way to record an image, but an entire business system has to be built around that image to take it from capture to delivery. Because of the volume at our studios, we never jump in—we take things one small step at a time.

The camera was fun to use but, because I'm very pleased with my Bronicas, I needed to figure out which products I wanted to produce with digital. I had to make sure that making the transition was worthwhile in the business sense. As I said, if

A camera is just a way to record an image, but an entire business system has to be built around that image to take it from capture to delivery.

you don't have a sound reason why going digital will positively impact your business, don't do it.

◆ NEW MODELS, DEPRECIATION AND DEBT

Another consideration is the depreciation of new digital equipment. Everyone knows that when they buy a new computer with all the bells and whistles, they'll see it advertised in the papers a month or two later for about 30 percent less. That same computer will cost 50 percent less six months later, and won't even be available a year after that. That's new technology!

If you think this doesn't happen with digital cameras, you're wrong. Professional quality cameras have been improving steadily for the last five to six years. With the introduction of the D-1 (Nikon), the S-1 (Fuji) and the D30 (Canon), the camera market has become competitive. No longer do photographers have one major brand and a few digital backs to choose from. Now each camera maker races to bring out bigger, better, lower-cost products to get to the top of the heap.

Because new models are constantly being introduced, depreciation occurs quickly with these products. A friend of mine who manages a camera store told me that many camera stores took major losses. They had a large inventory of the recent and older models of cameras and were priced down by the manufacturers. All of a sudden, camera stores had models in their inventory that were worth *half* what they were the day before.

Let's go back to the "wonder backs" that I priced four years ago. If I'd bought into digital at that time, I'd be $125,000 in debt (which would ride over the next ten to twenty years) for a product that would be outdated in two years. This is why I tell my employees never to finance a computer. Buy a really old one instead and have it upgraded, paying cash for both transactions. People are putting new computers on credit cards, and won't make the last payment until about

two years after they can no longer buy software for it.

Photographers are doing the same thing for digital systems. You can easily spend at least $50,000 for some of the complete systems that are on the market. That's a $50,000 debt. Now, if the purchase of this system will increase your business enough to create a $50,000 profit in the next three years (before this system is outdated), then purchasing the equipment is a sound business decision. Some studios use their digital systems for pictures of Santa or the Easter bunny at the mall, while others have gone to dog shows or horse races and were rewarded with instant portraits to give to the participants. While many studio photographers would consider this less than glamorous, this type of session will quickly pay for the new equipment.

◆ NEW TECHNOLOGY, NEW OPPORTUNITIES

Most photographers who've read some of my articles on digital think that I'm a die-hard film guy, and nothing could be farther from the truth. I've been using digital for years (when it made sense to

With digital, we can take a client from walking in for the appointment to ordering in about an hour.

Chelle

do so). I've found that capturing a digital image for my web site saved a huge amount of time when compared to scanning each negative. Since we add hundreds of images a year to our web site, it made sense to buy a digital camera. I've always looked for ways to use digital effectively. We've used digital to produce booklets, advertising and fast candids for our schools.

There are two things I decided about digital. There was no way I was going to start photographing events again, and I wasn't going to acquire debt for something that will have little or no worth once it's been paid off.

Because we specialize in seniors, I saw that the use of templates—predesigned layouts that house multipose images and feature graphics, names, etc.—would help pay for digital.

I told myself that I wouldn't enter into offering digital sessions until I could write a check for the camera(s) I needed. Most people are so into financing things that this is a hard concept to understand. Many people don't even buy food without charging it! Let me explain: you borrow money to buy a home. This home will last for the duration of the loan and will still have value when the last payment is made. You borrow money for a car, which depreciates, but it still has value when the loan is paid. Now, would you borrow money on a home that took thirty years to pay for, knowing that the home would fall apart after fifteen years? Would you take out a five-year car loan knowing that it would be a junker, parked in your driveway in only three years?

When you go digital, you've got to open your eyes to new opportunities for profit.

To justify the start-up costs of going digital, most photographers explain that the savings from a year's worth of film can buy a lot of equipment. I thought the same thing, until I talked with the photographers that had been in digital long enough for reality to set in. They said that digital is more expensive to shoot with than film. They explained that with film, you shoot the number of shots that come with a session, drop the film in a bag and move along. This saves our most valuable resource, time. With digital, most photographers shoot way too many frames and don't always stop with the number of clothing/background changes that come with a particular package. In the back of their minds, they think that without film, each shot is free—but it's not. Each frame has to be handled, viewed and stored. Whether this is your time or you must pay someone else to complete the job, the cost of handling all these files can easily cost much more than proofing a roll of film.

Once a photographer has spent their life savings on all this new camera equipment, they have to spend more on the software and powerful computers they need to handle all these digital files. Even though they've gone into debt, they still have the "digital glow." (This is that same starry-eyed look that a new car buyer has right up until the license plates and the first payment coupon arrive—then it's just another car.) Once the digital glow has faded, they're faced with the fact that they've just spent a bundle on what amounts to just another piece of equipment, when all is said and done.

When you go digital, you've got to open your eyes to new opportunities for profit. If you're going to offer digital sessions in the same manner as you do your film sessions (with no chance for additional profit to pay for the additional time that digital requires), stay with film. It makes no business sense to change, at least until the price of a digital camera is the same as a film camera.

I was determined not to switch to digital until I found a way to pay for the equipment and the time involved in the whole process. After looking around at the trade shows and playing with Photoshop, we came up with some products that we thought our clients would like. To keep our costs from increasing, we realized that we had to keep the time it took to produce these new items at a minimum. The truth is, special effects images take a considerable amount of time to produce. The funny thing is that it seems to take a little longer when you're working for clients rather than playing with the images from a test session.

When photographers first get started in digital, they are often swept away by the possibilities. Many photographers go into Photoshop and spend two hours creating a special-effect style portrait. They get excited about the creative possibilities, but don't think about how they'll manage their workflow when all of their clients want images like that. Can they charge enough for those portraits to pay for the time it takes to pro-

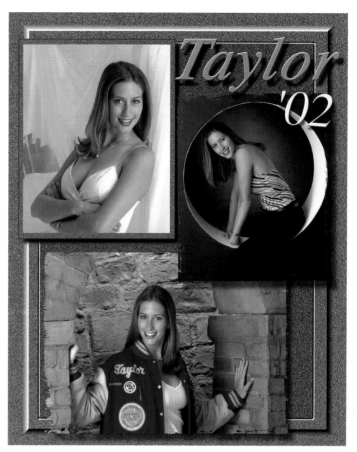

duce them? Can they continue to produce those same results without everyone in the studio working overtime? Will the images be priced sky-high and tick off clients who want the service but can't afford it?

We decided to try our hands at using pre-designed digital templates (these are 8x10-inch "pages" into which photos can be placed. These applications also offer the opportunity to utilize text and graphics to personalize the print). We produced the first templates from an older Kodak digital camera that we used for our web site. We also worked with Photoshop's simple special effects to add motion, blurs and text to our images when it was appropriate. The seniors loved the images, but when it came to paying more for them, they weren't so excited.

Profiting from New Technology. While producing the templates and special-effects images seemed promising, I didn't see it paying for digi-

Templates are easy to use. In minutes, you can personalize the design with text and your client's favorite images. These make great add-ons that are sure to increase your profits.

tal. I really wanted to start offering digital sessions, so I started looking into the sales methods that senior photographers were using. Most photographers generated proofs in one form or another to give to their clients on the day of the session. Then they committed a big mistake. They let them go home. First, they had the additional expense of proofing the session. Then, when the client's excitement was at its highest level (right after the session), they let them go home and hoped they'd return.

When I first got started in photography, we used "Trans-Vues" (35mm transparencies of each negative, produced by the lab) as proofs for each family session. The sales I had from these early sessions kept the studio alive. Clients that might not have returned to the studio if we'd given them proofs were placing large orders because they were

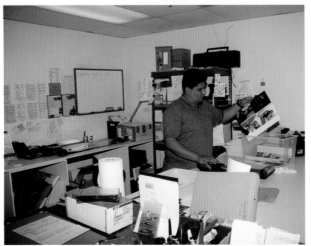

excited. It took additional time, but it was time well spent. I also started teaching several of our staff techniques to increase sales while the clients are excited—immediately after the session. I finally saw a way to get what I wanted, while increasing rather than decreasing profit potential.

Digital Previews and Sales. Photographers have always liked preview systems that show the client's proofs immediately after the session, because the excitement of the session and the ability to see the photographs immediately added to the sales. While this was the case with digital, the downside of the new system was that many clients still wanted traditional paper proofs—after all, every other studio still offered them.

With digital, we can take a client from walking in for the appointment to ordering in about an hour. In one hour I have a check for the session and an order in my hand. In an hour and fifteen minutes, there is a CD burned and ready to ship to the lab. No waiting, no fooling with negatives, no clients that don't return their proofs—it's all over when they walk out the door. The new preview system works well for the clients, too: they have a trained professional to help them select the best image for each pose/background idea—a professional who helps put a package together that fits their needs (which is how you should explain the digital proofing process to sell this idea).

To work out all the business challenges involved with taking the digital image from capture to

Top: Many photographers are making the switch from film to digital. When you make the switch, you'll need more space in your studio. You'll also need additional staff. Make sure you hire the right type of people. This is time-consuming production work. A talkative retoucher will drive up your production costs. Bottom: With a lab in-house, quality control is a must. Your production person has to check and recheck everything to make sure each image is flawless.

delivery, we started offering clients a choice: (1) they can choose a digital session and order immediately after the sitting or (2) choose a traditional session and receive paper proofs. It's worked out perfectly, in that we have digital sessions booked between our film sessions, and the staff can learn the digital process without becoming absolutely overwhelmed.

To me, the opportunity to present the proofs to clients digitally is exciting. I remember the days when I used to take families, children and couples and have Trans-Vues produced instead of paper proofs. We'd take these slide proofs into a viewing room and project them into an empty frame over a sofa. With a great deal of time invested in learning how to sell, there were some great sales that came from those appointments. As the studio grew and we moved toward specializing in seniors, however, time and client expectations put an end to this style of selling.

While we currently use computer stations that have 21-inch monitors for image selection, I'm currently looking into working with projectors in a subdued-lighting sales area and going back to the kind of sales appointment we used to offer on slides. There is no better way to sell wall portraits than to show them to people in the exact sizes they're considering.

Most clients decide on a portrait size before they ever select the pose they want to order. The

*Left: This is a Gretag Netprinter, which we just had installed. Most digital photographers are having to retouch, color correct, package and pay for the remakes from the lab, while paying the same price (or more) per unit as film. Since we're doing all the work anyway, how much harder is it to hit the print button? The Netprinter sells for under $70,000, prints up to 12x18-inch prints and produces an 8x10-inch print for about thirty-five cents. You do the math. **Right:** We have ten shooting areas in the Fresno studio. Each camera is tethered to a computer that's networked to the server. The server is a storage facility on your network. It keeps all your client files in one place until you can burn CDs and delete them from the hard drive.*

best way to determine the right portrait size is to consider the size of the focal point in the image. In a portrait, that focal point is the face of the person (or persons) in the portrait. You should be able to see and enjoy that portrait (see detail in the focal point) from any point in the room in which it hangs. A portrait size that reproduces the face 40–75 percent of life-size is a good start. The ideal size is one in which the focal point is at 100 percent life-size, but most people don't have the budget or the wall space for a portrait that size, especially of a full-length pose, or if there's more than one person in the photograph. With projected proofs, the client can easily see the effect that moving up—or down—a size will have on the portrait.

For families, we used to start the session with a 40x60-inch frame. We'd project each pose into the empty frame, creating what appeared to be a framed 40x60-inch portrait. After viewing all the poses in that size, we'd narrow the selection down to the single best pose for the wall portrait, without ever talking about size. Once we'd decided on the single best pose, we'd start talking about size. By that time, the client had been looking at their family portrait in a 40x60-inch size for about twenty minutes. He or she would've gotten used to seeing this pose in its proper size (for a family portrait). Once we started talking about size, we'd show how reducing the portrait to a 30x40-inch print would diminish the facial size, then we'd go back up to the 40x60-inch image.

This preview process added to the amount of time spent with each client, and I never sold a

A portrait size that reproduces the face 40–75 percent of life-size is a good start. The ideal size is one in which the focal point is at 100 percent life-size, but most people don't have the budget or the wall space for a portrait that size, especially of a full-length pose or if there's more than one person in the photograph.

40x60-inch family portrait. However, I did sell some 30x40s and a good number of 24x30s, which I'd never sold when I was using paper proofs. When you project various sizes in this manner, you're helping your client understand sizing and helping yourself by adding to your sales.

With the senior market that we deal with, I like to start off with a 30x40-inch frame because, typically, the average buyer will settle on a wall portrait that's two sizes down from what they've gotten used to seeing the pose in. I think that 20x24 inches is a nice size for a senior portrait, keeping in mind the facial size. Unfortunately, we had a few 20x24-inch prints made from the D30, and it just isn't quite there yet.

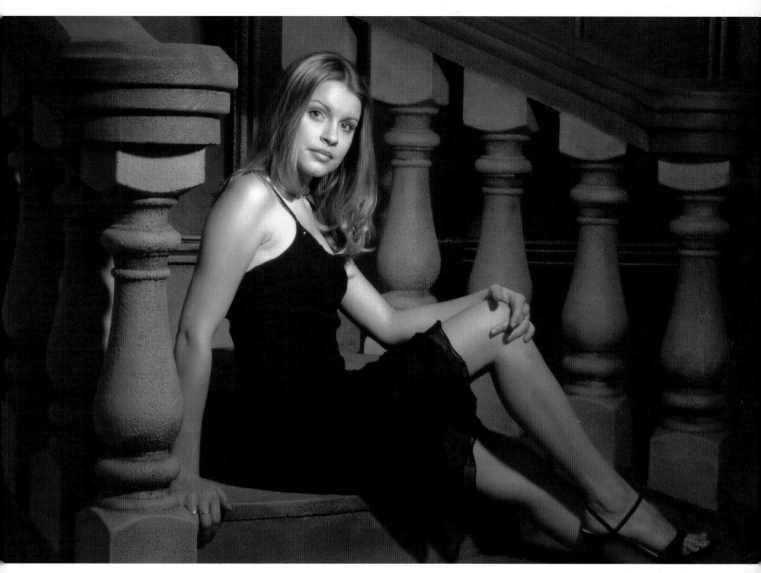

Most clients are nice people who appreciate what you create for them. However, the fear of the not-so-nice client is something that keeps many photographers from reaching their true potential, whether it's creative or financial.

By the time we get everything set up for this style of selling, the D30's big brother will be probably be out and size won't be an issue. But the point here is that even showing the images on a 21-inch monitor, the sales are better on average than with paper proofs—and that makes digital a viable alternative for our studio. For us, it makes business sense to use the new technology.

◆ THE PATH OF LEAST RESISTANCE

When the digital person from our lab came to the studio to help me set everything up, he asked me how we were going to show/sell the images from our digital sessions. I explained that we'd show them on the monitors. He was taken aback. He

told me that all the other labs with senior accounts were producing dye-sub/inkjet proofs that they sent home with the seniors. As a businessperson, I was shocked, but as a person who knows the way photographers are, I wasn't surprised.

Let's be honest—proofs are still around because photographers don't want to deal with selling their own work, not because clients insist on having them. It's easier to give clients proofs and let them walk out without looking at them than it is for a photographer to take a chance on having to listen to someone criticize their work. I know some photographers who go so far as to mail them directly to a client's home. Talk about avoidance!

Selling work is much harder for most photographers than creating it.

Selling work is much harder for most photographers than creating it. I did it for many years because I had to. I forced myself to learn how to do it well and, because of that, I got through those difficult startup years. I wasn't afraid to become more than what I was, and that's why I eventually succeeded, while so many other photographers who started out at the same time failed. The fear of going digital is the same fear that has kept proofing alive and well for years. It's the fear of failure. It's the fear that maybe someone will complain about your work, about the fact that you're doing photographs digitally, about something!

From what I've seen in dealing with clients over the past nineteen years, 95 percent are very nice and appreciate what you do for them. Then there are the 5 percent who complain about everything. This 5 percent has raised being a pain in the neck to an art form just to get more out of anyone they do business with. They use words like *compensation*. As a matter of fact, any time we hear the word compensation, we turn it into a game to see how much they are going to ask for. "I didn't like one of my seven poses as well as the other six!" "I want compensation . . . I think you should return my sitting fee and give me a free package. If not, I'm calling the Better Business Bureau!" Have you ever heard anything like that, or do the 5 percent who've overdosed on assertiveness training live in my area?

The path of least resistance is one that many photographers take. They let their fear of the dangerous 5 percent outweigh the potential of the 95 percent. Ignorance breeds fear, education breeds confidence. The easiest way to overcome fear is education. At no point in your life should you ever stop learning.

There's an old saying that ignorance breeds fear and intelligence breeds confidence. For many people, ignorance is truly bliss. If they learn too much they'll just have more things to worry about. This is similar to the "No brains, no headaches" way of thinking.

I don't believe that there are stupid people out there, just people who lack the self-confidence to become more than what they are. Intelligence, like wealth, is an easy enough thing to create. There are thousands of readily-available books, videotapes, classes, seminars and web sites—on any subject in the world—that you can learn from on any given day.

Education

There are countless books, videotapes, classes, seminars and web sites that you can use to help you grow as a photographer and a businessperson.

Why do some people achieve great things with little formal education, while others achieve little with a great education? The answer lies in self-confidence or believing in one's self. (I apologize for all the inspirational sayings I use in my books. You see, my father must've been a philosopher in a former life. He used to tell me, "Whether you think you can or can't, you are right," "You can do anything you set your mind to," and "As long as a man thinks of himself as 'green' he is growing, it's only when he considers himself grown that he begins to die." He was like Confucius in disguise. Between my father telling me I could achieve anything and my mother telling me I should be an actor because I'm so handsome, I suffered from overconfidence for quite a while!).

At the age of fourteen, I knew what I wanted to do. A week into photography class in high school, I knew. I went out and got a job working nights and weekends. By the end of that school year I had my own studio setup and darkroom and had taken out a loan to buy my first Hasselblad (with my parents' help). By the time I was sixteen, I was working full time at my job and photographed my first wedding for a paying client.

Being a firm believer in the "I can do anything" way of thinking, I decided to graduate early from school and rent a small studio space to work in. My father believed in me, so he gave his consent. He told my high school counselor, "He knows what he's doing." This was a moment that I will never forget. He knew he'd taught me well and

believed enough in me at sixteen to know that I knew the direction I wanted my life to take. He was an amazing man.

I kept the studio space for about four months. It provided a place to shoot and meet with the few clients I had, but wasn't really worth the money it was taking out of my paycheck. So I moved all my stuff back into my parents' house. My mom was so happy to have one of her bathrooms converted into a darkroom again!

For the next three years I studied, planned to open my studio and worked to buy more equipment. Finally, when I was twenty years old, I

At the age of fourteen, I knew what I wanted to do. A week into photography class in high school, I knew. I went out and got a job working nights and weekends. By the end of that school year I had my own studio setup and darkroom and had taken out a loan to buy my first Hasselblad.

opened my studio. About a month after I opened, it happened. I developed the same affliction that happens to most young photographers that start out dangled from a shoestring . . . total fear! I had that sinking feeling you get when you start to question just how good you really are and what qualifies you to be in the position you're in. I was struck by the realization that I'd read countless books and shot hundreds of rolls of film during test sessions, but had no formal education, no apprenticeship, nothing. All of a sudden the confidence that I'd always felt left me.

A formal education is beneficial. It gives you confidence. It helps you avoid the questions that every person without a degree asks him- or herself. When dentists or doctors do this, they glance over at that diploma from the Grenada School of Medicine and feel pretty full of themselves.

College is only one of many avenues to higher learning. Ask any successful professional and they'll tell you that they read constantly. I'm always looking for books on sales, marketing, money, the psychology of success and, once in a while, something on photography (just kidding!). People increase their intelligence by learning more about the world around them.

Learning is never complete. If you ever feel that you've learned it all and don't need to learn any more, just remember, "As long as man thinks of himself as green, he is growing. It is only when he considers himself grown that he begins to die." When I meet a photographer who thinks he's grown, I know I'm meeting a photographer who's becoming a dinosaur. I've never met a photographer who was so overwhelmingly talented and so monumentally successful that he should think he is done learning.

I will concede that the more you know about a profession, the harder it is to learn more. When I first started out in photography, I went to conventions/seminars and it seemed that each one was better than the one before. The photographers conducting the workshops seemed like all-knowing gurus of photography. The saddest day in my professional life was when I went to a seminar, looked at the photographer's work and realized I was a much better photographer than he was. Looking at his studio, I realized I made a heck of a lot more money than he did. Yes, it was sad . . . good for me, but sad!

Once I reached this point, going to seminars lost its appeal. I'd go and be bored stiff, learning one or maybe two new things. This was a bad time for me professionally. I felt I'd learned all there was to learn. At this same time I started writing my first book. After all, with such a volume of wisdom, I wanted to share it.

I sat down and started writing. I wrote down all I knew about photography, and my book was twelve pages long. At this point, I decided I might have a few more things to learn. So, I went back to school (in a manner of speaking). I wanted to learn more about photography, but I also wanted to learn more about learning, about teaching, about being a success and about money. At the end of the '80s, you couldn't turn around in a bookstore without seeing countless books on success and wealth. People were greedy and, according to Michael Douglas's character in *Wall Street*, "greed is good!"

The knowledge of how to make money is something that no one can take from you.

Well, greed *isn't* good—understanding and responsibility are. Knowledge, not money, is the real determining factor for wealth. People can lose vast sums of money, but the knowledge of how to make money is something that no one can take from you. This is where the old saying comes from, "You give a hungry person a fish and you satisfy his hunger for the moment, but if you teach him to fish, you satisfy his hunger for a lifetime."

Well, after two years of reading, learning and experimenting, I finally finished that first book. I thought it was pretty good. My wife wasn't talking to me because of all the time I'd spent on it, but it was done. I met with a publisher, and he agreed to publish the book—if I rewrote it. He wanted a book on contracting high schools, not just another book on senior photography. So I agreed and started rewriting it.

Eventually, the book was published. I started receiving phone calls and letters from photographers who'd read it and liked it (this was before e-mail). Everyone told me I should start giving lectures. This scared me to death, but it was something I'd always wanted to do. My father had gone with me to a few programs on photography and I'd always told him that lecturing was one thing I wanted to accomplish in my life. I wanted to be good enough at what I did that others in this profession would want to come and listen to me speak.

Once again, I had to start studying. If I was going to get up and give a lecture, I wasn't going to look like an idiot. Shortly after the book was published, I was asked to speak at a convention and then run some seminars. The first time was a little rough, but by the time we gave the seminars, it went really well. The people enjoyed themselves throughout the day and I accomplished a lifelong ambition. After it was over, I told my wife it would take a lot of money to get me to do it again. To give a program and have the people learn from it—and stay awake—takes a great deal of preparation and rehearsal. This was time away from family and my business and, for the amount of money it generated, it wasn't worth it.

Many photographers would look at all the time I spent studying to learn how to give a presentation a waste of time. After all, I could have been studying lighting and posing. Giving a presentation is hard work, but I think it's worth it.

Many photographers would look at all the time I spent studying to learn how to give a presentation a waste of time. After all, I could have been studying lighting and posing. Although this knowledge didn't get used in the way I'd intended, it has benefited my business. As a businessperson, I'm always speaking in front of small to large groups of people, whether it's a staff meeting, a classroom of students or an entire graduating class of students. Not looking like an idiot in front of these people is an advantage in my business. Knowledge is never lost. It may not be used in the way you might expect it to be, but it's never lost.

Knowledge often comes when you least expect it. In learning more about the business, and with the size of my businesses growing, I started looking at seminars and classes a little differently. Instead of expecting to be overwhelmed with

usable information, I realized that all I needed to get was just one usable idea, one thing I didn't know before and going to that program would be worth my time.

Realizing that there aren't too many photographers who do exactly what I do, I started going to programs that my staff photographers thought were a little bit crazy. Though I work with nothing but seniors, I'd go to programs on children, weddings or families. They couldn't understand why I'd want to waste my time. They, like most younger people (wow! saying that made me feel so old), expect learning to be condensed and specific. In attending these seminars, I learned some of the most valuable business information I've ever come across—and I learned it from people who didn't even do what I do.

◆ LEARNING FROM OTHERS
I learned to work properly with more than one person at a time from my doctor. I learned how to set up the studio waiting rooms (which have to handle the crowds during the last few days prior to yearbook deadlines) from McDonalds.

I discovered that people will wait in a long line as long as they don't see exactly *how* long it is, which is why the line goes all the way around the building. Instead of using one large waiting room, we use several smaller ones. The client feels he is making progress going from room to room and, although he may have to wait for thirty to forty-five minutes, the wait somehow seems shorter.

I learned commonsense customer service from restaurateurs. I've developed many of my best-selling sets from programs based on everything from boudoir to children's photography. We have to do a little modifying, make the backgrounds a little bigger and a little less bedroom-like, but it

works. All these ideas and many more didn't come prepackaged in the guide to professional senior portrait photography, but they've helped make my studios as successful as they are.

When it comes to learning, many people come up with all kinds of excuses. Getting an eduction is a little like the dieting thing. Everyone is going to start a diet next week. They plan to start next week, though they've gone from 150 to 180. They say "next week" as they top 200 and, finally, when they have a face that looks like a pie (flat and round) they give up on dieting because they have so much weight to lose it seems overwhelming.

When people feel that they are falling behind others in their business, they think, "I need to start learning more in these areas," but they rationalize that they are too busy, too stressed, too *whatever* to start now, so they put it off. Finally, they end up being let go or losing their business and, instead of learning new skills over time, they have to go back to school to be completely retrained, which certainly seems overwhelming.

Companies have tried to make learning as easy as possible. You can pop in an audio tape and listen to it as you're driving. If you live in a large city, this amounts to several hours of study each week, turning an unpleasant commute into a classroom experience that can change your life forever.

◆ THE BUSINESS SYSTEM
Many photographers have a hard time learning about anything that isn't photography. I can't count the number of photographers that work at the studio who are a product of the local city college photography program and think their creativity will set them apart and ensure their success.

Any photography business is made up of four parts: marketing/advertising, management, money and last, as well as least, photography. If you disagree that photography is the least important part, you should save yourself a lifetime of

You can sell millions of mediocre products with a spectacular business system, but you won't sell any spectacular products without good business systems.

I know this is hard for photographers to buy into. It's hard on an artistic person's ego, but you can look at any business and see that what I'm saying is true. The old restaurant saying, "You don't sell the steak, you sell the sizzle" is so true. Buying decisions aren't based on reality, but on expectations. In any given town, there are restaurants that

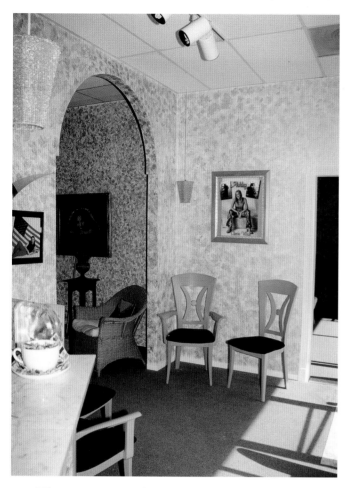

These are two of the seating areas in our studio. I like to keep the clients moving from one seating area to another, much like they do in a doctor's office. It makes clients' waiting time seem shorter.

grief: go out and get a great job and make photography your hobby. If you think that making money and attracting clients is less important than your skill, you'll never make a great living in photography or, for that matter, in any professional service.

Look at the millions of dollars made every year by the national studios and mall photography companies. If creativity and the quality of photography were really so important, these companies wouldn't last a week, but they thrive, year after year. Why? Because they realize what most photographers don't, that the business system is more important than the service or product being sold.

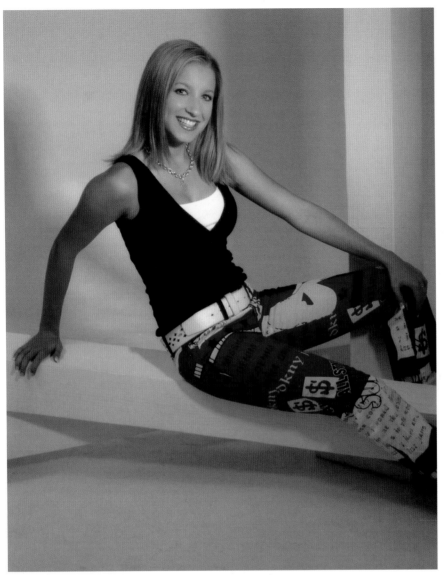

Many clients look at national/mall photography companies as inexpensive, convenient and easy to work with. Most clients look at photography studios as expensive, not convenient and difficult to deal with.

serve great food at competitive prices. You can get a table at one of these places on any Friday or Saturday night. Other restaurants serve average food and command higher prices—and there's a two-hour wait! People aren't buying the food, they're buying the experience.

In the studio (or any other service-oriented business) experience is packaged, prepared and advertised to prospective clients through the business system. Just like the quality of food has little to do with which restaurant is hot, the quality of its images has little to do with the success a photography company will enjoy. Many clients view national/ mall photography companies as inexpensive, convenient and easy to work with. Most clients look at photography studios as expensive, inconvenient and difficult to deal with.

If you doubt this, think about each type of studio. One is located in a climate-controlled mall, one is located in a building with cheap rent. One is open eleven hours a day, seven days a week, has pleasant younger employees that are trained to be nice to everyone, and given incentives for larger sales. The other has an older professional who usually has no training in customer service and an ego the size of Alaska. He/she is there seven hours a day, four to five days a week and while he/she will work at other times, don't expect him or her to have a good attitude about it. Then you have price. While most national/mall photographers aren't really that much cheaper, they constantly advertise specials and have become masters at getting bigger sales through add-ons and speculation work.

Most photographers have no idea why they charge what they do—they only know that the three competitors they managed to get price lists from charged about the same price.

Most photographers fail not because of their photography, but because of the lack of training and the failure of the business system. Know this: a photography business is made up of four parts: marketing/advertising, business management, financial planning and photography. Which are the most important? Look at your bookshelf. There should be four times as many books on marketing/advertising as photography. There should be three times as many on management (customer service, business management, packaging, merchandising, pricing/profit, etc.) and twice as many books on money (success, investing, etc.). If you learn in these proportions, you will be as successful as you are talented. You'll become a businessperson and photographer—who really knows how to sell photographs—not just a photographer who doesn't sell much of anything. The only person that can afford to be content with just their photography skills is the hobbyist, which (for the sake of their families) is exactly what some "professional" photographers should be.

The need to develop good businesses skills is a concept I try to explain to the photographers in our studios. Some will probably be with our company (or another) for the rest of their lives, while others will eventually open their own studios. I see the disappointment and boredom come over these photographers when they are doing anything other than photography. I explain to them that by helping the clients, taking orders or handling problems they will improve their odds of success more than they will when taking pictures, but most of the time my advice falls on deaf ears.

Many photographers don't realize that—like photography—learning to operate a business takes time. They expect to read one book on marketing and have it nailed. Nope! When you got into photography, you probably read, took a lot of photos (putting your knowledge into practice) and then read some more. If you know photography well,

congratulations, you've learned how to produce the products that you'll sell from your photography studio. To make a profit and achieve success, however, you'll have to become as good a businessperson as you are a photographer.

I see the disappointment and boredom come over some photographers when they are doing anything other than photography. I explain to them that by helping the clients, taking orders or handling problems they will improve their odds of success more than they will when taking pictures.

Balancing Your Life

Balancing your life is difficult in any profession, but it's especially hard for photographers. Most photographers live at their studios when they first open them, which isn't a bad thing because at that point in their lives most photographers can't afford a place to live anyway. The struggle continues for a number of years and then, if they're lucky, they start to see a light at the end of the tunnel. The rent starts getting paid almost every month, and some months it's not even late!

It seems that no photographer knows what to do after that. In those early days, you start working on habits that'll be hard to break. When I first got over the financial hump and was able to pay my bills and actually have something to eat, I felt like I had to be at the studio all the time, because that's what I was used to. When our children came along, the studio was doing much better and my wife started scheduling me off one day in the mid-

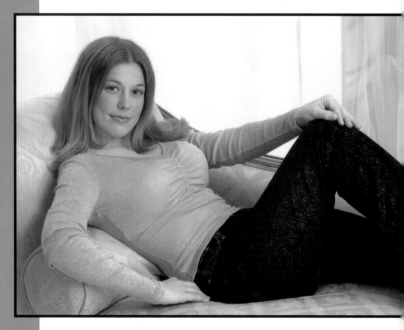

Balancing your life is difficult in any profession, but it's especially hard for photographers. For most, things are tough in the beginning. The demands of the studio take a lot of energy and time. So much, in fact, that obtaining "success" seems more important than enjoying your life.

of the week to spend in their life will never be creative or as successful as they could be. It's like not being able to see the forest for the trees. When you have no life outside of the studio, you can't see the studio for what it is, a business. Without time away from the studio, you can't get new perspectives and ideas.

It sounds crazy, but I've come up with the ideas for the outline of every book or article I've written when I was on vacation. You may create in the studio, but it's been proven that people get their most creative ideas when they are relaxed at a place other than their office or business.

Something as simple as a trip to the local mall can be better than a day-long seminar. Take a walk through Macy's, Saks' or Blooming-dale's and you'll see all the new colors that are in. This will help you figure out what colors to introduce into the backgrounds you paint, and what colors you should introduce into your sets and set components. Look at the in-store ads. These are the images that are setting the standard for beauty and style in the eyes of your buying public. Look at people as they are shopping, sitting and talking,

blend fabrics, colors, textures and props. Write down any new idea or flash of inspiration you come up with. So many good ideas are lost because people think they will remember them but don't. Get into the habit of carrying around a

Believe it or not, you can learn a lot from a trip

tebook, or a pocket computer to keep
new ideas.

is essential to your success and creativ-
d to do something that has nothing to
otography at least two days out of every
those two days, you can't take any

Balancing your life is about providing for yourself
and your family the same luxuries that you allow
for your business. Like I said before, making a large
sum of money doesn't matter to most photographers
when it comes to buying their child a pair of expen-
sive tennis shoes, but when it comes to a new camera,

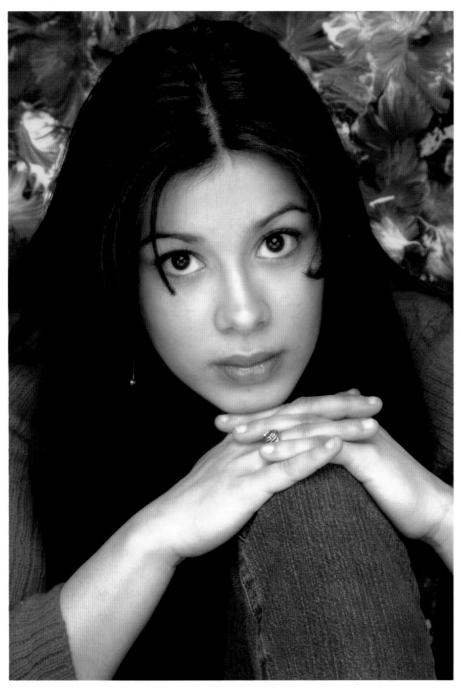

To be a true success in this profession you need to grow with your business. You have to top your client's greatest expectations. Don't be afraid of change, look for the opportunity in it.

The days you select to take off aren't always going to be ideal. If you have children, you naturally want to be off on Saturday and Sunday, but if you're like most studios, the weekends are the busiest time of the week.

Many photographers feel entitled to take Saturdays and Sundays off, like other professionals. Well I hate to tell you this, but until people are legally required to have their portraits taken strictly on weekdays, you'll never have all of your weekends free.

Weekends are a great time to rake in a big profit. In fact, some studios get so busy on weekends that they can pretty much take the rest of the week off. Now that's a fair trade!

To be truly successful, you need to feel like a success not only in business, but in every other aspect of your life as well. You're a photographer, but you have many other roles to play and many other people who need your time and attention. You're a husband/wife, boyfriend/girlfriend, father/mother, and a son/daughter—and I know that each of you is a friend to someone. Each relationship you're in needs your time and energy.

While many photographers race off to PPA meetings or to hang around the camera store in the morning, they find it difficult to carry on

a conversation with their wife or husband, children or family. Any conversation that doesn't include a discussion on photography doesn't interest them. This takes its toll on any and all relationships.

Success isn't achieved by grand gestures and big deals. It's an attitude, a state of being that comes over you slowly in time. Many people expect to jump from poverty to prosperity in a single leap. They buy their lotto tickets and listen for the hottest stock tip to keep the dream of being wealthy alive. And of course, wealth to many people equals success.

Many people also think that once success is achieved, stress and problems will be a thing of the past. The only "stress-free" state that a human being can ever achieve is death. We do our best when we're challenged the most. Problems in life just seem to change—they never go away. You go from worrying about paying the rent to worrying you're going to lose what you've acquired.

Life is a game that constantly changes. Just about the time you get really good at being a kid, you become a teenager. Then you get really good at being a teenager and you become an adult. You get really good at dating and then you get married. You get really good at being a couple, then you have children. Then, when you finally get really good at being a parent, your children leave home, and you have to start working on being a couple again. And these changes, struggles and problems continue throughout your life, but "it beats the only alternative," as my father would say.

Balancing your life is about providing for yourself and your family the same luxuries as your business. Like I said before, making a large sum of money doesn't matter to most photographers when it comes to buying their child a pair of expensive tennis shoes, but when it comes to a new camera, all of a sudden money matters. I think there should be a success chart for photog-

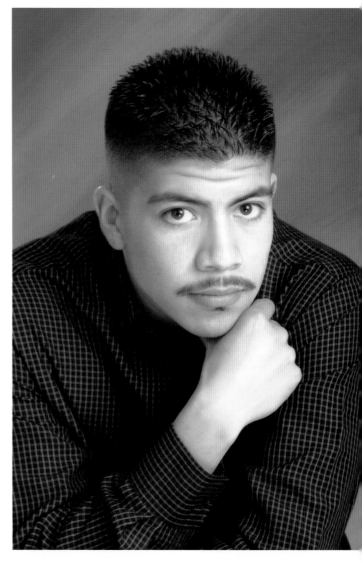

Balance is something we're all looking for. Remember to strive to create a balance—your family deserves as much time and attention as your business.

raphers. If you shoot with a 35mm because you can't afford medium format, your child can wear New Generic tennis shoes from Kmart/Walmart. If you shoot with medium format, your kids should wear Nike™/Reebok™ tennis shoes. If you shoot digital or Hasselblad, your children should wear whatever shoes they want.

This chart would also be useful for all other aspects of life, too. If you're barely scraping by, you have to take two weeks' vacation a year, and going camping is okay. If you shoot digital or Hasselblad, you take off at least four weeks a year with your family/spouse and take at least one vacation that requires a passport. Think about it.

Two things would happen. First, photographers would have much happier home lives and second, they would think long and hard before they'd spend big bucks on equipment. They would make sure that this new equipment would make additional profit to pay for all these "home" expenses.

Balance is something we're all looking for. Your family deserves as much of your time, attention and resources as your business. Photographers that spend freely for their studios pinch every penny when it comes to their family. I've seen photographers that work in a palace and live in a shack. A photographer might tell his wife he wants to buy a new $200,000 printer, but later mentions that she doesn't need a bigger diamond in her wedding ring or to go on a romantic cruise. Why are so many photographers divorced? I don't know!

To be a true success in this profession you need to grow with your business. You have to top every one of your client's greatest expectations. Don't be afraid of change, just look for the opportunity in it. Problems are only problems if you don't find the lesson in them that life is trying to teach you. And, as

my father would say about worrying, "people spend 95 percent of their time worrying about things that never come to pass and the other 5 percent of the time worrying about things that are out of their control." Spend your time thinking of solutions rather than dwelling on problems and, most importantly, don't try going down that crowded path, hoping you'll end up at a different destination.

Good luck!

Spend your time thinking of solutions rather than dwelling on problems and, most importantly, in your quest for success, don't try going down that crowded path, hoping you'll end up at a different destination.

Index

Other Books from
Amherst Media

Additional titles by this author . . .

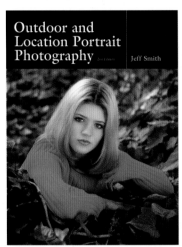

Outdoor and Location Portrait Photography

Outdoor portraiture offers countless opportunities to create beautiful, personality-filled, memorable images. In this book, you'll learn to select the best equipment, identify the perfect light, choose great settings and pose your subjects to create beautiful portraits your clients will love. In addition, you'll learn the business skills you need to schedule efficient location shoots, market outdoor sessions to your clients and maximize your profits. $29.95, list, 8½x11, 128p, full color, 100 photos, order no. 1632.

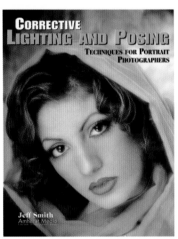

Corrective Lighting and Posing Techniques for Portrait Photographers

This complete, step-by-step guide focuses on the challenges of photographing the average client. Beginning with the consultation, Smith offers suggestions on how to tactfully address clients' problem areas. Smith teaches the reader how to utilize special poses or suggest clothing that will downplay figure problems, double chins and more, yielding dramatic improvements to each portrait. Posing for full-length and head shots is covered in detail. $29.95, list, 8½x11, 128p, full color, 100 b&w/color photos, order no. 1711.

Professional Digital Portrait Photography

Digital portrait photography offers a number of advantages—both creatively and financially. Yet, because the learning curve is so steep, making the tradition to digital can be frustrating. Author Jeff Smith shows readers how to shoot, edit and retouch their images—while avoiding common pitfalls. With this book, readers will learn techniques for creating dazzling photographs, from shooting digitally, to editing the images, to retouching and adding special effects. You'll see how to get the best results from your lab, and how to educate your clients about this exciting technology! $29.95 list, 8½x11, 128p, 100 full-color photos, order no. 1750.

Basic 35mm Photo Guide,
5th Edition
Craig Alesse

Great for beginning photographers! Designed to teach 35mm basics step-by-step—completely illustrated. Features the latest cameras. Includes: 35mm automatic, semi-automatic cameras, camera handling, *f*-stops, shutter speeds, and more! $12.95 list, 9x8, 112p, 178 photos, order no. 1051.

How to Operate a Successful Photo Portrait Studio

John Giolas

Combines photographic techniques with practical business information to create a complete guide book for anyone interested in developing a portrait photography business (or improving an existing business). $29.95 list, 8½x11, 120p, 120 photos, index, order no. 1579.

Black & White Portrait Photography

Helen T. Boursier

Make money with b&w portrait photography. Learn from top b&w shooters! Studio and location techniques, with tips on preparing your subjects, selecting settings and wardrobe, lab techniques, and more! $29.95 list, 8½x11, 128p, 130+ photos, index, order no. 1626

Profitable Portrait Photography

Roger Berg

A step-by-step guide to making money in portrait photography. Combines information on portrait photography with detailed business plans to form a comprehensive manual for starting or improving your business. $29.95 list, 8½x11, 104p, 100 photos, index, order no. 1570.

Professional Secrets for Photographing Children
2nd Edition

Douglas Allen Box

Covers every aspect of photographing children on location and in the studio. Prepare children and parents for the shoot, select the right clothes capture a child's personality, and shoot storybook themes. $29.95 list, 8½x11, 128p, 80 full-color photos, index, order no. 1635.

Photo Retouching with Adobe® Photoshop®
2nd Edition

Gwen Lute

Designed for photographers, this manual teaches every phase of the process, from scanning to final output. Learn to restore damaged photos, correct imperfections, create realistic composite images and correct for dazzling color. $29.95 list, 8½x11, 120p, 60+ photos, order no. 1660.

Watercolor Portrait Photography
THE ART OF POLAROID SX-70 MANIPULATION

Helen T. Boursier

Create one-of-a-kind images with this surprisingly easy artistic technique. $29.95 list, 8½x11, 128p, 200+ color photos, order no. 1698.

Marketing and Selling Black & White Portrait Photography

Helen T. Boursier

A complete manual for adding b&w portraits to the products you offer clients (or offering exclusively b&w photography). Learn how to attract clients and deliver the portraits that will keep them coming back. $29.95 list, 8½x11, 128p, 50+ photos, order no. 1677.

Innovative Techniques for Wedding Photography

David Neil Arndt

Spice up your wedding photography (and attract new clients) with dozens of creative techniques from top-notch professional wedding photographers! $29.95 list, 8½x11, 120p, 60 photos, order no. 1684.

Posing and Lighting Techniques for Studio Photographers

J.J. Allen

Master the skills you need to create beautiful lighting for portraits of any subject. Posing techniques for flattering, classic images help turn every portrait into a work of art. $29.95 list, 8½x11, 120p, 125 full-color photos, order no. 1697.

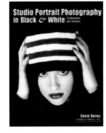

Studio Portrait Photography in Black & White

David Derex

From concept to presentation, you'll learn how to select clothes, create beautiful lighting, prop and pose top-quality black & white portraits in the studio. $29.95 list, 8½x11, 128p, 70 photos, order no. 1689.

Basic Digital Photography

Ron Eggers

Step-by-step text and clear explanations teach you how to select and use all types of digital cameras. Learn all the basics with no-nonsense, easy to follow text designed to bring even true novices up to speed quickly and easily. $17.95 list, 8½x11, 80p, 40 b&w photos, order no. 1701.

Professional Secrets of Natural Light Portrait Photography

Douglas Allen Box

Learn to utilize natural light to create inexpensive and hassle-free portraiture. Beautifully illustrated with detailed instructions on equipment, setting selection and posing. $29.95 list, 8½x11, 128p, 80 full-color photos, order no. 1706.

Master Posing Guide for Portrait Photographers

J. D. Wacker

Learn the techniques you need to pose single portrait subjects, couples and groups for studio or location portraits. Includes techniques for photographing weddings, teams, children, special events and much more. $29.95 list, 8½x11, 128p, 80 photos, order no. 1722.

Portrait Photographer's Handbook

Bill Hurter

Bill Hurter has compiled a step-by-step guide to portraiture that easily leads the reader through all phases of portrait photography. Covering indispensable tips for shooting and darkroom techniques, as well as posing and lighting solutions, this book will be an asset to experienced photographers and beginners alike. $29.95 list, 8½x11, 128p, full color, 60 photos, order no. 1708.

Photographer's Lighting Handbook

Lou Jacobs Jr.

Think you need a room full of expensive lighting equipment to get great shots? Think again. This book explains how light affects every subject you shoot and how, with a few simple techniques, you can produce the images you desire. $29.95 list, 8½x11, 128p, 130 full-color photos, order no. 1737.

Professional Marketing & Selling Techniques for Wedding Photographers

Jeff Hawkins and Kathleen Hawkins

Learn the business of successful wedding photography. Includes sections on setting and achieving your goals, conducting consultations, using direct mail, print advertising, internet marketing and much more. $29.95 list, 8½x11, 128p, 80 photos, order no. 1712.

High Impact Portrait Photography

Lori Brystan

Learn how to create the high-end, fashion-inspired portraits your clients will love. Features posing, alternative processing and much more. $29.95 list, 8½x11, 128p, 60 full-color photos, order no. 1725.

Photographers and Their Studios

CREATING AN EFFICIENT AND PROFITABLE WORKSPACE

Helen T. Boursier

Tour the studios of working professionals, and learn their creative solutions for common problems, as well as how they optimized their studios for maximum sales. $29.95 list, 8½x11, 128p, 100 photos, order no. 1713.

The Art of Color Infrared Photography

Steven H. Begleiter

Color infrared photography will open the doors to an entirely new and exciting photographic world. This exhaustive book shows readers how to previsualize the scene and get the results they want. $29.95 list, 8½x11, 128p, 80 full-color photos, order no. 1728.

Traditional Photographic Effects with Adobe Photoshop

Michelle Perkins and Paul Grant

Learn to use Photoshop to enhance your photos with handcoloring, vignettes, sepia toning effects, soft focus and much more. Every technique contains step-by-step instructions for easy learning. $29.95 list, 8½x11, 128p, 150 photos, order no. 1721.

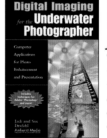

Digital Imaging for the Underwater Photographer

Jack and Sue Drafahl

This book will teach readers how to improve their underwater images with digital imaging techniques. This book covers all the bases—from color balancing your monitor, to scanning, to output and storage. $39.95 list, 6x9, 224p, 80 color photos, order no. 1727.

The Art of Bridal Portrait Photography

Marty Seefer

Learn to give every client your best and create timeless images that are sure to become family heirlooms. Seefer takes readers through every step of the bridal shoot, ensuring flawless results. $29.95 list, 8½x11, 128p, 70 full-color photos, order no. 1730.

Photographer's Filter Handbook

Stan Sholik and Ron Eggers

Take control of your photography with the tips offered in this book! This comprehensive volume teaches readers how to color-balance images, correct contrast problems, create special effects and more. $29.95 list, 8½x11, 128p, 100 full-color photos, order no. 1731.

Beginner's Guide to Adobe® Photoshop®

Michelle Perkins

Learn the skills you need to effectively make your images look their best, create original artwork or add unique effects to almost image. All topics are presented in short, easy-to-digest sections that will boost confidence and ensure outstanding images. $29.95 list, 8½x11, 128p, 150 full-color photos, order no. 1732.

Professional Techniques for Digital Wedding Photography

Jeff Hawkins and Kathleen Hawkins

From selecting the right equipment to building an efficient digital workflow, this book teaches how to best make digital tools and marketing techniques work for you. $29.95 list, 8½x11, 128p, 80 full-color photos, order no. 1735.

Lighting Techniques for High Key Portrait Photography

Norman Phillips

From studio to location shots, this book shows readers how to meet the challenges of high key portrait photography—from setting up lights to effective metering techniques to clothing and props selection—metering to to produce images their clients will adore. $29.95 list, 8½x11, 128p, 100 full-color photos, order no. 1736.

Beginner's Guide to Digital Imaging

Rob Sheppard

Learn to select and use digital technologies that will lend excitement and provide increased control over your images—whether you prefer digital capture or film photography. $29.95 list, 8½x11, 128p, 80 full-color photos, order no. 1738.

Professional Digital Photography

Dave Montizambert

From monitor calibration, to color balancing to creating advanced artistic effects, this book provides photographers skilled in basic digital imaging with the techniques they need to take their photography to the next level. $29.95 list, 8½x11, 128p, 120 full-color photos, order no. 1739.

Group Portrait Photographer's Handbook

Bill Hurter

With images by over twenty of the industry's top portrait photographers, this indispensible book offers timeless tips for composing, lighting and posing dynamic group portraits. $29.95 list, 8½x11, 128p, 120 full-color photos, order no. 1740.

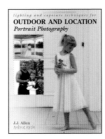

Lighting and Exposure Techniques for Outdoor and Location Portrait Photography

J. J. Allen

The changing light and complex settings of outdoor and location shoots can be quite challenging. With the techniques found in this book, you'll learn to counterbalance these challenges with techniques that help you achieve great images every time. $29.95 list, 8½x11, 128p, 150 full-color photos, order no. 1741.

Toning Techniques for Photographic Prints

Richard Newman

Whether you want to age an image, provide a shock of color, or lend archival stability to your black & white prints, the step-by-step instructions in this book will help you realize your creative vision. $29.95 list, 8½x11, 128p, 150 full-color/b&w photos, order no. 1742.

The Art and Business of High School Senior Portrait Photography

Ellie Vayo

Learn the techniques that have made Ellie Vayo's studio one of the most profitable senior portrait businesses in the United States. Covers advertising design, customer service skills, clothing selection, and more. $29.95 list, 8½x11, 128p, 100 full-color photos, order no. 1743.

The Best of Nature Photography

Jenni Bidner and Meleda Wegner

Have you ever wondered how legendary nature photographers like Jim Zuckerman and John Sexton create their captivating images? Follow in their footsteps as these and other top photographers capture the beauty and drama of nature on film. $29.95 list, 8½x11, 128p, 150 full-color photos, order no. 1744.

Beginner's Guide to Nature Photography

Cub Kahn

Whether you prefer a walk through a neighborhood park or a hike through the wilderness, the beauty of nature is ever present. Learn to create images that capture the scene as you remember it with the simple techniques found in this book. $14.95 list, 6x9, 96p, 70 full-color photos, order no. 1745.

Photo Salvage with Adobe® Photoshop®

Jack and Sue Drafahl

This indispensible book will teach you to digitally restore faded images, correct exposure and color balance problems and processing errors, eliminate scratches and much more. $29.95 list, 8½x11, 128p, 200 full-color photos, order no. 1751.

The Art of Black & White Portrait Photography

Oscar Lozoya, with text by Peter Skinner

Learn how master photographer Oscar Lozoya uses unique sets and engaging poses to create black & white portraits that are infused with drama. Includes lighting strategies, special shooting techniques and more. $29.95 list, 8½x11, 128p, 100 full-color photos, order no. 1746.

The Best of Wedding Photography

Bill Hurter

Learn how the top wedding photographers in the industry transform special moments into lasting romantic treasures with the posing, lighting, album design and customer service pointers found in this book. $29.95 list, 8½x11, 128p, 150 full-color photos, order no. 1747.

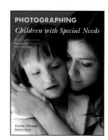

Photographing Children with Special Needs

Karen Dórame

Like other parents, the moms and dads of special needs children want to document special moments with beautiful photographs. This book explains the symptoms of spina bifida, autism, cerebral palsy and more, teaching photographers how to safely and effectively capture the unique personalities of these children. $29.95 list, 8½x11, 128p, 100 full-color photos, order no. 1749.

The Best of Children's Portrait Photography

Bill Hurter

See how award-winning photographers capture the magic of childhood. *Rangefinder* editor Bill Hurter draws upon the experience and work of top professional photographers, uncovering the creative and technical skills they use to create their magical portraits. $29.95 list, 8½x11, 128p, 150 full-color photos, order no. 1752.